Photorealistic
COLORED PENCIL
DRAWING TECHNIQUES

Step-by-Step Lessons for Vibrant, Realistic Drawings!

COCOMARU

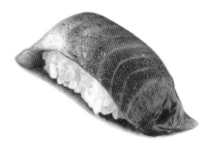

TUTTLE Publishing

Tokyo | Rutland, Vermont | Singapore

Why I Wrote This Book

We often see pictures on television and the Internet that look like they could be mistaken for photographs. I am sure there are many people who think "Wouldn't it be fun to create pictures like that?" I was one of them.

"Let's give it a try!" That was the first step that brought me to where I am today.

In this book, I show you how to draw realistic pictures using colored pencils, a familiar drawing material that everyone has used at some time or another. I have included a variety of drawing techniques that I have mastered over the years. You can also draw more realistic pictures using various other art materials.

You can start by drawing with the colored pencils you have at home. You may try drawing with your children or friends. Take it easy and enjoy the relaxing effects of drawing.

When you learn to draw, you will see the world differently. You can take photos of beautiful landscapes with your camera and try drawing them, or you can record the growth of your children or grandchildren in pictures. It is fun to try drawing in your own way, taking your cues from the drawing methods introduced in this book.

I hope that this book will help you discover the joy of drawing and that it will be of some help to you in your future art life.

—Cocomaru

Contents

▶ The estimated durations indicated in this book are the approximate times taken by the author to complete each work.
▶ Outline drawings are provided for all the pictures, which can be enlarged and copied for your use.

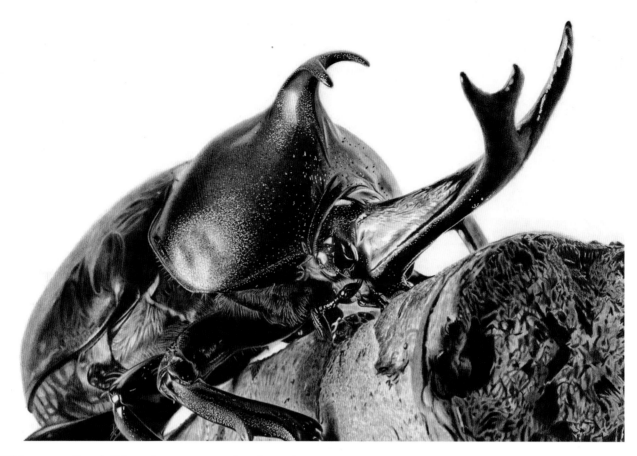

"Rhinoceros Beetle" (2019) **MEDIUM:** colored pencil **SIZE:** 11⅔ × 8¼ inches (29.7 × 21 cm)

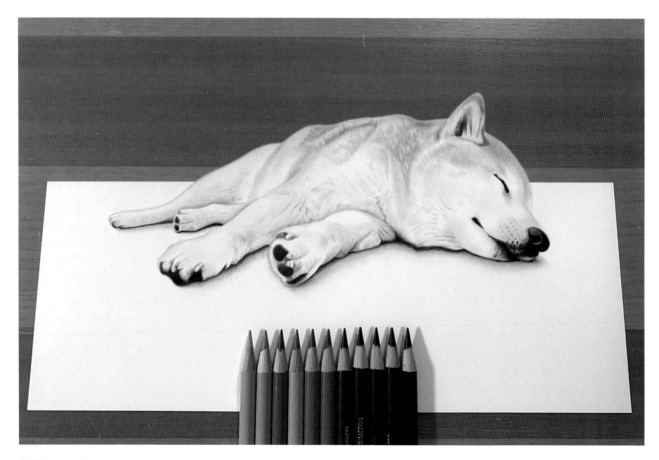

"Shiba Inu" (2020) **MEDIUM:** colored pencil and PanPastel® **SIZE:** 11⅔ × 8¼ inches (29.7 × 21 cm)

"Eagle" (2021) **MEDIUM:** colored pencil and PanPastel® **SIZE:** 8¼ × 11⅔ inches (21 × 29.7 cm)

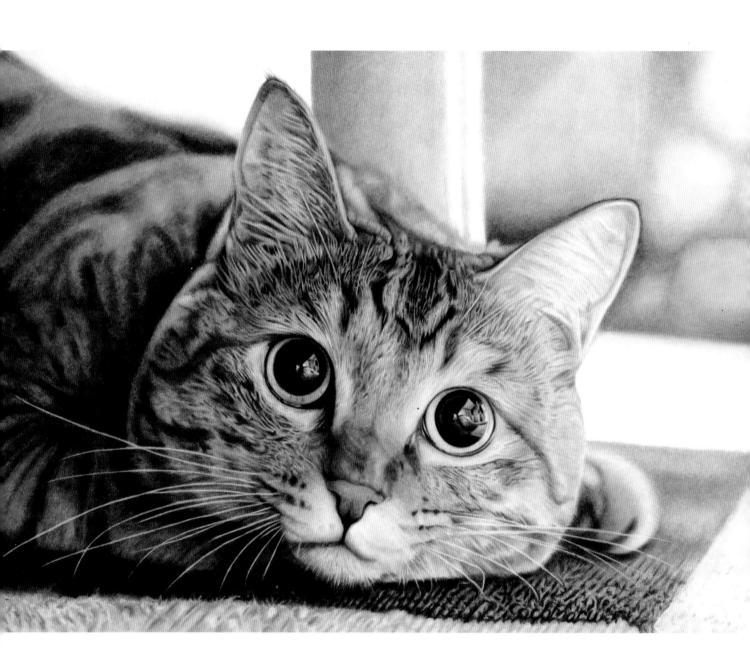

"Cat" (2019) **MEDIUM:** colored pencil and PanPastel® **SIZE:** 11⅔ × 8¼ inches (29.7 × 21 cm)

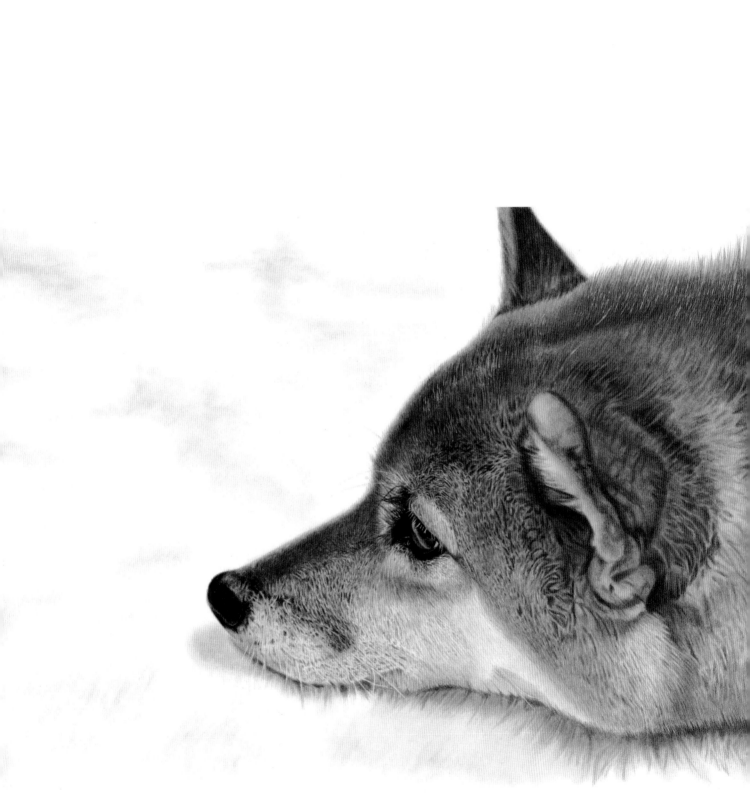

"Shiba Inu" (2019) **MEDIUM:** colored pencil and PanPastel® **SIZE:** 11⅔ × 8¼ inches (29.7 × 21 cm)

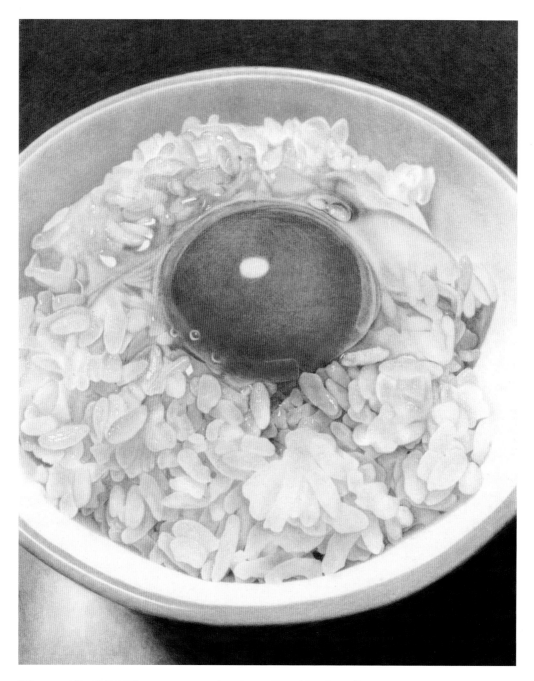

"Egg on Rice" (2020) **MEDIUM:** colored pencil and PanPastel®
SIZE: 8¼ × 11⅔ inches (21 × 29.7 cm)

"Rice Omelette" (2020) **MEDIUM:** colored pencil and PanPastel®
SIZE: 8¼ × 6 inches (21 × 15 cm)

"Umeboshi Pickled Plum" (2021)
MEDIUM: colored pencil and PanPastel®
SIZE: 8¼ × 6 inches (21 × 15 cm)

"Sushi" (2019)
MEDIUM: colored pencil
SIZE: 8¼ × 6 inches (21 × 15 cm)

"Pineapple" (2020) **MEDIUM:** colored pencil and PanPastel®
SIZE: 6 × 8¼ inches (15 × 21 cm)

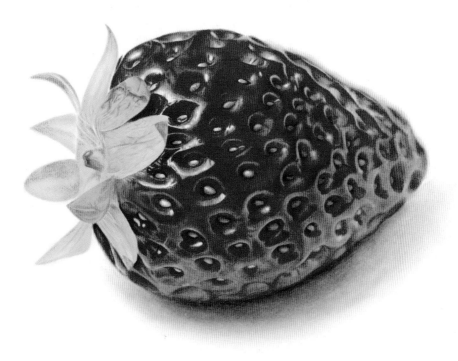

"Strawberry" (2019) **MEDIUM:** colored pencil and PanPastel® **SIZE:** 11⅔ × 8¼ inches (29.7 × 21 cm)

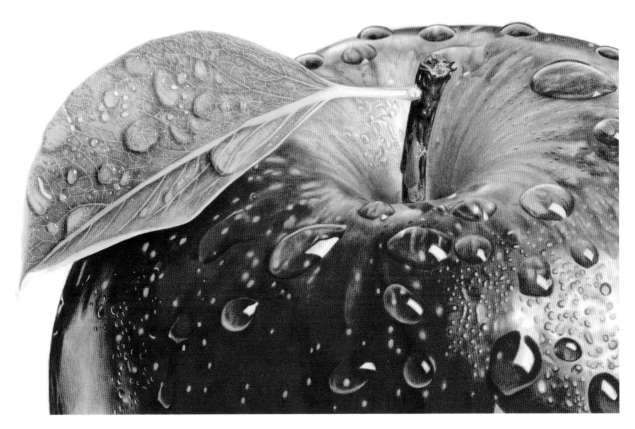

"Apple" (2019) **MEDIUM:** colored pencil and PanPastel®
SIZE: 11⅔ × 8¼ inches (29.7 × 21 cm)

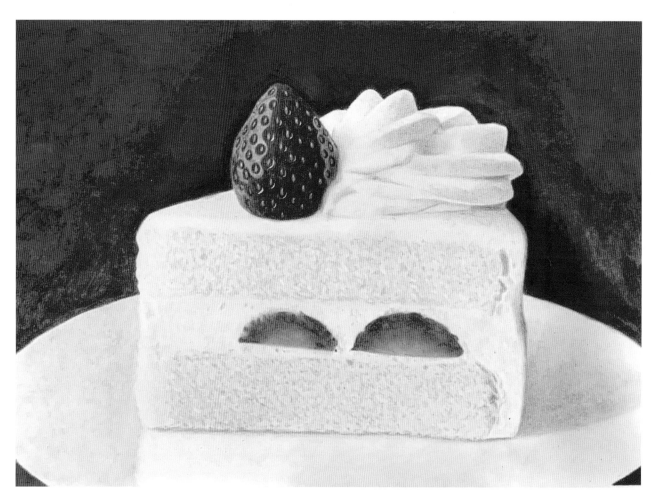

"Strawberry and Cream Cake" (2019) **MEDIUM:** colored pencil
SIZE: 8¼ × 6 inches (21 × 15 cm)

"Japanese Sweet" (2019) **MEDIUM:** colored pencil and PanPastel®
SIZE: 8¼ × 11⅔ inches (21 × 29.7 cm)

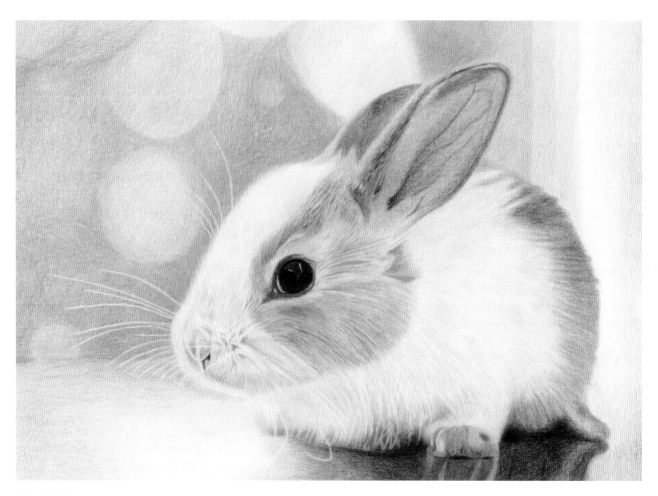

"Rabbit" (2018) **MEDIUM:** colored pencil
SIZE: 11⅔ × 8¼ inches (29.7 × 21 cm)

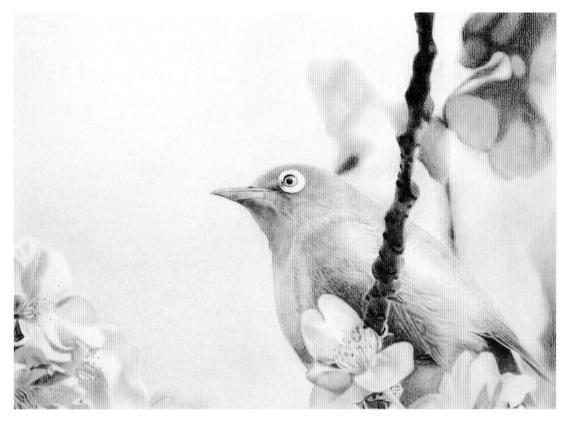

"Warbling White-Eye" (2019) **MEDIUM:** colored pencil and PanPastel®
SIZE: 11⅔ × 8¼ inches (29.7 × 21 cm)

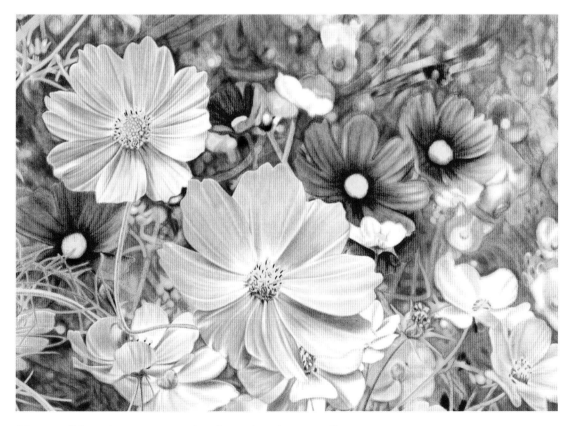

"Cosmos" (2019) **MEDIUM:** colored pencil and PanPastel®
SIZE: 11⅔ × 8¼ inches (29.7 × 21 cm)

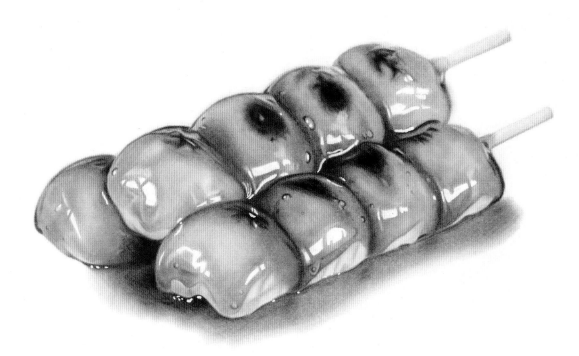

"Mitarashi Dango (Dumplings)" (2020) **MEDIUM:** colored pencil **SIZE:** 8¼ × 6 inches (21 × 15 cm)

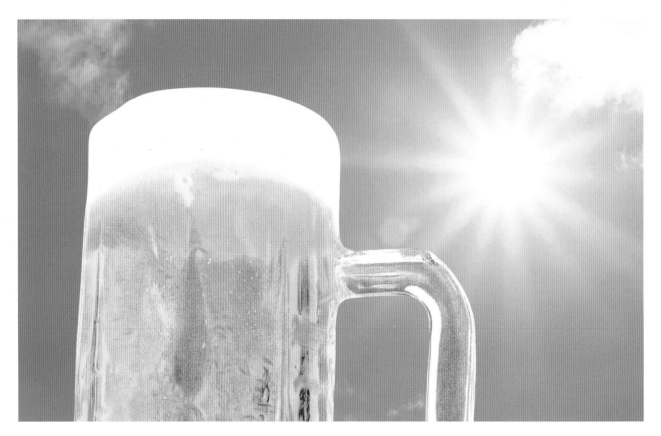

"Beer" (2018) **MEDIUM:** colored pencil and PanPastel® **SIZE:** 11⅔ × 8 ¼ inches (29.7 × 21 cm)
▶ (Composite with the sky image)

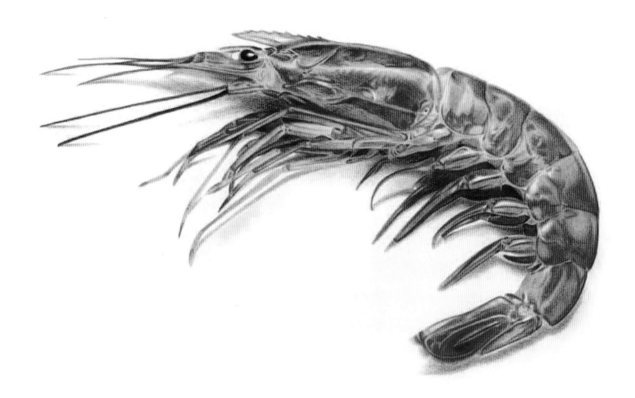

"Shrimp" (2019) **MEDIUM:** colored pencil **SIZE:** 8¼ × 6 inches (21 × 15 cm)

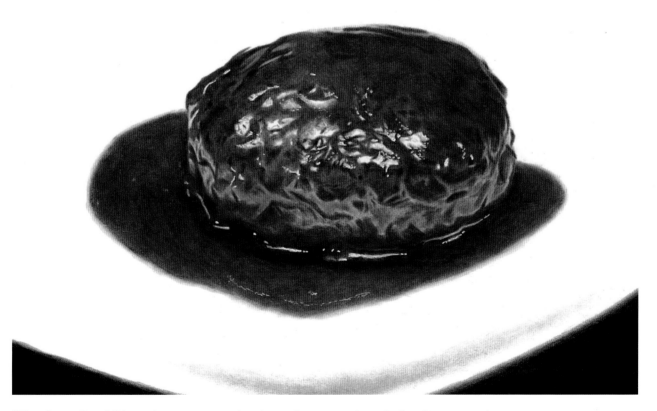

"Hamburg Steak" (2019) **MEDIUM:** colored pencil **SIZE:** 8¼ × 6 inches (21 × 15 cm)

 # Drawing Materials Used in This Book

Before you start drawing realistic pictures, here are my recommended art materials. However, it is not necessary to get all of them. The fun part of realistic drawing is to think of substitutes and to use things that you can find around you in your daily life.

Colored Pencils
Faber-Castell Polychromos 120 Color Set

I have been using this type of colored pencil since I started drawing realistic pictures. The lead is not too hard, nor too soft, and the balance is good, making it easy for even beginners to handle. These colored pencils also produce good color development, suitable for layered application, and the color adheres well to the paper.

PanPastel® Artists' Pastels

This is what I use when I draw with colored pencils and I cannot layer on the color thickly enough and end up with light areas. It is as if the fine particles of the PanPastel® fill in all the irregularities on the surface of the paper. The pastels also produce deep textures and details, especially when the colors are graduated.

Soft Pastels

The particles of soft pastels are fine, and it is easy to apply the colors smoothly. Soft pastels are recommended because they are readily available. They can be shaved with a utility knife to make a powder or applied directly onto the paper.

Utility Knife

I use this utility knife mainly to cut the eraser in a holder. Cutting the tip of the eraser at an angle makes it easier to erase in small areas.

Mechanical Pencil or Pencil

Either of these can be used to draw rough sketches or to trace faint lines.

Eraser Holder with Eraser

I use this to correct fine lines or to erase parts of lines. It is also effective when you want to reveal the highlight of a strand of hair after using PanPastel®.

White Pen (Marvy Le Plume)

The color of this pen does not bleed. Because the color is opaque, it is used when you want to depict a strong highlight. Fine tip pens are convenient.

Steel Stylus

A steel stylus is ideal for depicting things clearly and strongly, such as whiskers. If you score the paper first with a stylus and then go over it with colored pencils, the white grooved lines will remain.

Kneaded Eraser

Use this to erase the traced lines of your preliminary drawing. It is indispensable because it allows you to change its shape depending on the area you want to completely erase or just erase faintly.

Kent Paper or Bristol Paper

I used to focus on black-and-white pencil drawings, and I have loved Kent paper ever since. The smooth surface of the paper is very easy to draw on. It is versatile for all types of drawing and is easily available. Bristol paper is a good alternative.

Pencil Sharpener

I use this type of sharpener for colored pencils. It has two side-by-side sharpening holes: one for sharpening the wood and lead, the other for sharpening the lead only, which is very useful when you want to sharpen the tip of the lead.

Masking Tape

Masking tape is useful to prevent drawing paper from moving when the drawing is in progress. The four edges of the paper are secured with masking tape, which does not damage the paper when removed.

Mini Applicator

I use this when applying pastels and PanPastel®. Use one applicator per color, as using a single applicator on multiple colors will result in muddy colors.

Brush

This is used to remove fine colored pencil dust from the paper during the process of drawing or at the completion stage.

Pastel Fixative

I use this on a drawing after it is finished to help the colors stay in place and prevent dust and smudging. It also prevents deterioration of the work, such as color fading.

Expressing Realism

COCOMARU'S "SECRET" DRAWING TECHNIQUES

Even if you are not familiar with colored pencils or PanPastel®, you can use my methods to get very close to realistic expression without much effort. In this book, I will show you how to create motifs of various textures, and how to finish each piece or part of a picture in a methodical way. By applying multiple layers of color, you can create realistic colors and shapes. I will explain the secret techniques that you should know before drawing.

Refer to flat photographs rather than actual objects

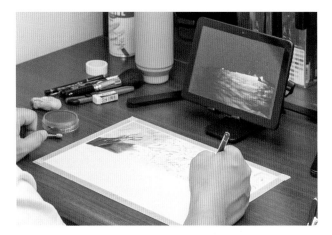

● Refer to photos displayed on a tablet device

It is very difficult for an amateur to see and depict a real three-dimensional object. It is easier to draw something if you use a photo displayed on a PC, tablet or smartphone as a reference. When using a printed photo as a reference, enlarge it as much as possible. It is recommended that you prepare a high-resolution image.

It is easier to draw if the size of the screen and the size of the drawing are the same.

● Observe details carefully while zooming in

One of the most important techniques for achieving a precise drawing is to observe the object carefully. Always zoom in on the area to be drawn. You will be able to see fine lines, dots, hidden details and colors. Reproducing them faithfully is the most important way to create a realistic picture.

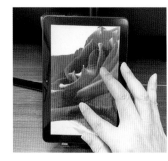

When displaying a picture on a PC, tablet or smartphone, zoom in and observe carefully.

● Draw as shown in the photo

Color the drawing while looking at the colors in the photo on the screen. The areas of the photo that are in focus should be sharply defined. The out-of-focus areas should be blurred. The key is to depict the photo faithfully.

● Do not soil the paper

Place a sheet of paper or tissue under your hands to prevent rubbing or staining the paper during the drawing or coloring process. Sweat and grease on your hands can also cause stains.

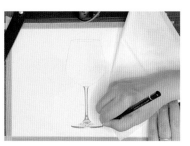

COCOMARU'S PERSONAL TIP!

● Relax when you draw

When I draw, I do it in a very relaxed state of mind. Sometimes I listen to music, and sometimes my wife and I watch TV while I draw. Try not to rush—draw when you feel relaxed.

ABOUT COLORED PENCILS

Colored pencils are easy to draw with. There are two types of pencil: water-based and oil-based. Oil-based pencils are preferred for realistic drawings. The wide variety of colors they come in allows you to choose exactly the color you want to use.

⬤ Tips for choosing colors

The color of the pencil lead is different from the color on paper. When choosing a color, carefully observe the picture on the screen and compare it with the color of the pencil lead. As you draw, enjoy coloring in the image by layering other colors on top of previous ones.

⬤ Test each color on a piece of scrap paper

Once you have chosen a color, be sure to test it on another sheet of the same type of paper before applying it on the actual drawing paper. Colored pencils cannot be erased, so there is no going back once you begin drawing. When applying the same color over a previous layer, overlap the color to make sure both colors are the same.

⬤ How to use colored pencils in the Cocomaru style

I don't change the way I hold my colored pencils for planes and lines. For fine lines, I sharpen my colored pencil and then use the pointed end. I constantly rotate my colored pencil to find the side with the right amount of lead.

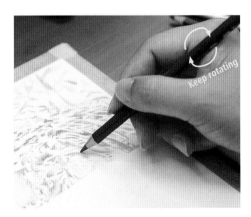

⬤ Keep your pencil strokes short

Instead of drawing a line all at once or covering a large area with broad strokes, use light pressure and draw carefully with small strokes with the tip of the pencil.

Keep the strokes to about this size, and draw a few at a time.

Draw long lines with small strokes also.

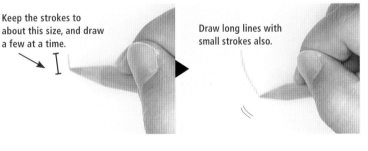

⬤ Complete each part carefully

In order to achieve the same effect as in the photo, completely finish each part of the image before going on to another part. Only look at the part to be drawn and explore the colors there. The goal is to achieve the same colors as in the photo by applying layers of color.

ABOUT PANPASTEL® ARTISTS' PASTELS

To make realistic drawings look even more realistic, this book introduces a technique that uses both colored pencils and pastels, in particular PanPastel®. PanPastel® artists' pastels are characterized by their fine powdery consistency and good spreadability. They are indispensable for realistic drawings.

● How to use PanPastel®

I cover any uneven surfaces on the paper using the fine grains of PanPastel® to fill in the areas that cannot be filled with colored pencils. PanPastel® artists' pastels work very well with colored pencils and add texture and detail to a picture.

● Applicators

To apply color, use an applicator, a stick-like tool with a small sponge on the end. It is used to pick up the color to be applied directly to the paper.

● Soft pastel sticks

If it is difficult to obtain PanPastel®, I recommend using soft pastel sticks in powder form by shaving them with a knife. They can be used in the same way as PanPastel®.

CHECK!

Use one applicator per color. If different colors mix on the sponge, the picture will become muddy.

Blend

PanPastel® pastels work best when applied evenly over large surfaces. They are ideal for creating beautiful gradations.

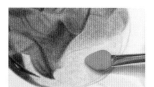

Express depth

By layering PanPastel® on top of colored pencils, you can achieve a sense of depth. Try applying the pigment in a patting motion as if you were putting on face powder.

Alternate layers of colored pencil and PanPastel®

Even if you think a shape or color is a little complicated, you can finish it in sections, so observe the section you are working on carefully, and after several color layers you will get closer to your ideal depiction. Use colored pencils and PanPastel® artists' pastels to fill in the fine tooth of the paper.

To get close to the colors in the photo, colored pencils and PanPastel® artists' pastels are layered on top of each other repeatedly, a little at a time.

COLORED PENCIL **PANPASTEL®** **COLORED PENCIL** **PANPASTEL®**

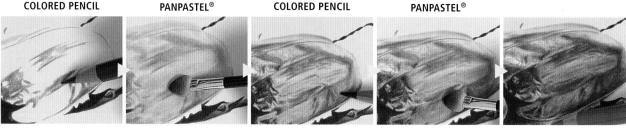

 Secret Techniques

Achieving Photorealism with Four Techniques

COCOMARU STYLE

What are the main elements for expressing realistic paintings? After thinking hard about this question, I came up with four techniques that are unique to the Cocomaru style. The combination of each of these elements makes realistic depictions stand out even more. Try your best to master them.

Let us master four techniques for depicting light, shadow, texture and perspective!

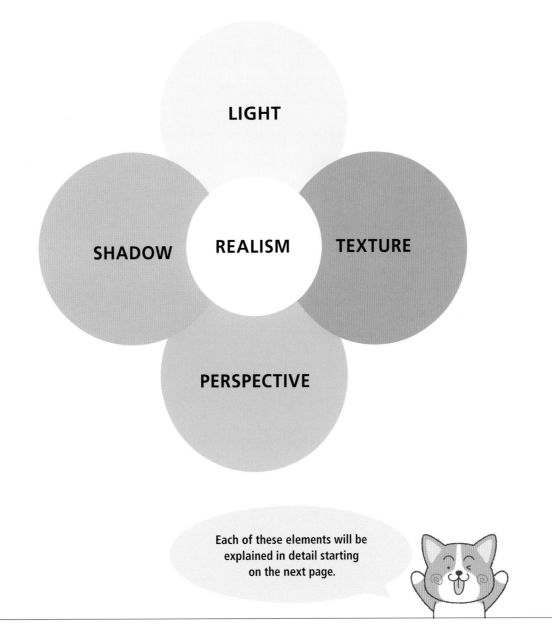

Each of these elements will be explained in detail starting on the next page.

Light Techniques

The basic principle of effective light is to take advantage of the white color of the paper. The absence of color creates a natural light effect. However, lighting methods vary from one subject to another, so here are some key points.

Here are the three main light techniques presented in this book!

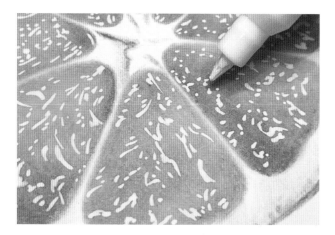

WHITE PEN

Specular highlights

Use a white pen to finish a picture in order to create the sharp highlights that give the fruit its juicy appearance. The special feature of this white pen is that it can clearly be seen even when painted over dark colors.

UTILIZE THE WHITE OF THE PAPER

Light reflecting off the surface of liquid

Sometimes we want to create a gradation of light while blurring the image. For example, to create a liquid-reflected light such as that on curry sauce, we would not paint the light but would instead use the white color of the paper to depict it. The light areas are lightly colored to blend in with the paper. The light reflected off the curry sauce is relatively uniform, but a white pen is not suitable here because it is too opaque.

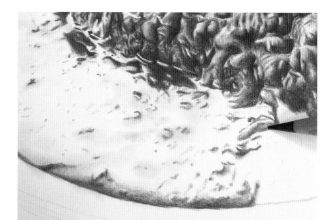

WHITE PENCIL

Light shining through transparent materials

Use a white pencil on the area where light shines through the marble. The colors blend softly as they are layered on top of each other.

Shadow Techniques

When creating a realistic drawing, it is important to depict shadows well. The shadows should match the characteristics of each object, whether it is a living creature, glass, metal, food and so on. By creating shadows that reflect the qualities of the object, you can create a sense of three-dimensionality and depth in your work.

● How to apply shadows

The way shadows are applied increases the realism of the image by several degrees, so this is a key point that needs to be understood. Adjust the shadows by looking at the density of the shadows in the photo on the screen that will be used as the subject. The key point is whether or not the object is floating off the ground. Shadows at a distance should be drawn lighter and more diffuse, while those that fall close to an object should be stronger and darker.

Realism is greatly enhanced by drawing shadows and detailed shading.

● Use a tissue to blur the shadow

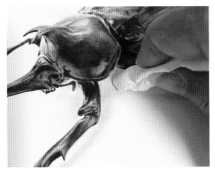

● Use PanPastel® to depict soft light

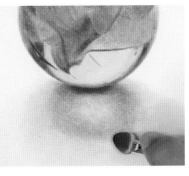

● Use colored pencils to draw strong shadows

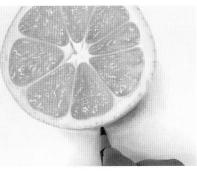

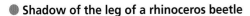

● Render even small shadows in fine detail

In addition to the shadows of the object, the shading of details on the subject is also important. For example, by drawing details ranging from the shadow of a bird's face to the shadow of a grain of rice, you can create a more three-dimensional effect. If you are drawing with a photo on a screen as reference, enlarge the image as much as possible.

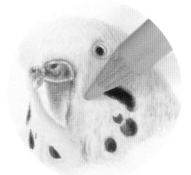

● Shadows on a bird's face

The shadow on the bird's face is a warm gray. Warm colors are appropriate for living creatures. There are many different types of grays, so be sure to experiment. Layer yellow over the base color to find the most suitable shade.

● Shadow of the leg of a rhinoceros beetle

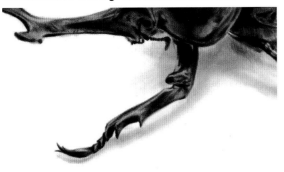

The shadow of the beetle's foreleg falls very close to the legs, and should be defined with a relatively dark color.

● Use PanPastel® to depict soft light

Focus on each grain of rice. Using a light gray color, apply the shadows gently and carefully.

Texture Techniques

The key to expressing the texture of each subject is to create distinct darks and lights. Be aware of the differences between the dark and light areas. It is important to enlarge the motif on a PC, tablet or smartphone screen before drawing details. Refer to a photo that is of as high a resolution as possible.

◉ Draw in fine patterns and details with care

◉ The texture of fur

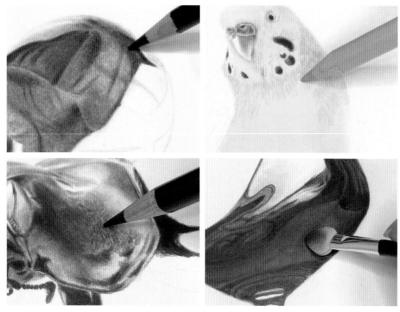

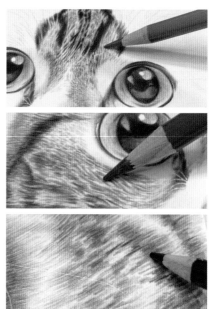

The ribbons of color within marbles, the feathers of a bird, the texture of a beetle's thorax, the color of swirling wine ... when you look closely at the details in the image, you can see many different textures, so try to reproduce them faithfully.

Draw a cat's fur strand by strand. Move the colored pencil in the direction of growth.

> I am constantly researching how I can realistically express the texture of an object with colored pencils and PanPastel® pastels.

Tools that bring out texture

ERASER IN A HOLDER

Apply color for the copper plate and the cat's ears with PanPastel® pastels, and then erase portions of the colors with a sharp eraser in a holder. After erasing, a faint trace of the base color is left behind, giving the work a sense of harmony.

This stylus was originally used as a tool for embossing fold lines for paper crafts. To express delicate, fine hairs, etc., in realistic drawings, use the stylus to engrave lines in the paper before coloring. The color will not be applied to the grooves and a white line will remain.

STEEL STYLUS

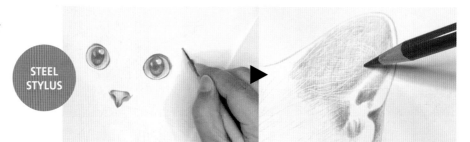

Perspective Techniques

Regardless of the subject, the closer it is observed the more clearly it is depicted, and the farther away it is the more blurred it will be. The pencil pressure and color depth should be adjusted slightly as you draw farther back in the image, and the color should be made lighter. PanPastel® pastels are also very useful for blurring.

⬤ **Rhinoceros beetle example**

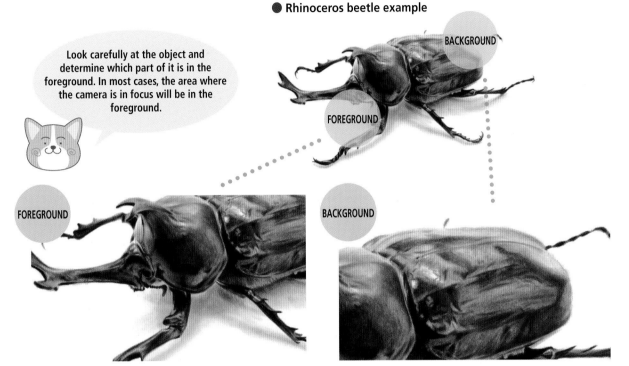

Look carefully at the object and determine which part of it is in the foreground. In most cases, the area where the camera is in focus will be in the foreground.

In the case of a rhinoceros beetle, the head is in the foreground, so it should be drawn clearly.

⬤ **Rice curry example**

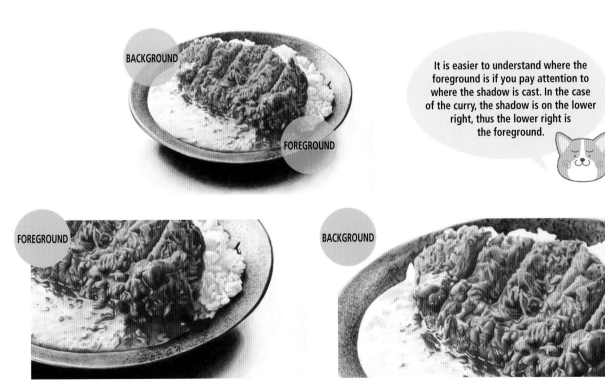

It is easier to understand where the foreground is if you pay attention to where the shadow is cast. In the case of the curry, the shadow is on the lower right, thus the lower right is the foreground.

Secret Techniques

COCOMARU STYLE
Photo Compositing Magic

A dog that looks as if it is lying on a desk. A beer illustration that looks like a photograph. The finished realistic drawing can be clipped or combined with a photograph using an image-editing application, heightening the sense of realism.

CUT-OUT
This is a method of digitally photographing a completed realistic illustration, and then removing the top part of the background in Photoshop. The three-dimensional effect is compounded.

COMPOSITE
This is a method of clipping the scanned, digitized motif and combining it with a photograph.

1
Fix the camera for a diagonal overhead view.

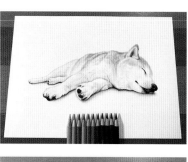

2
Take separate pictures of the desk from the same angle.

3
Crop the top half of the photo using Photoshop, and combine it with the photo of the desk.

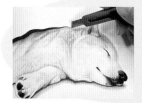

You can make a color printout and cut out the top part with a utility knife or scissors to achieve a bird's-eye view!

1
Complete an illustration of the beer only. The key point is to paint the blue of the sky that can be seen through the glass mug handle.

2
The image is captured with a scanner, clipped in Photoshop leaving the foam part intact, and then composited with a photo of the sky.

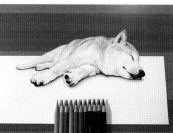

+

3
Completed.

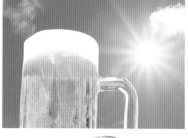

🐶 **COCOMARU'S PERSONAL TIP!**

Fixative — Before framing a finished realistic picture, spray it with a fixative to ensure that the colors do not spread. It also prevents the colors from fading. Give it a try!

Before You Begin Drawing

Once you have understood the materials and key points, it is time to start drawing. First, secure the drawing paper firmly to the desk with masking tape, and then position the tablet or other device in front of you.

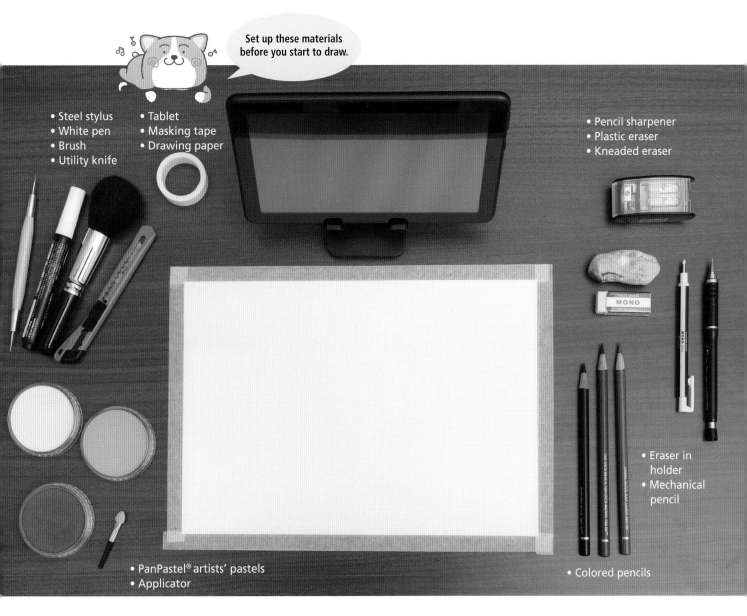

Set up these materials before you start to draw.

- Steel stylus
- White pen
- Brush
- Utility knife

- Tablet
- Masking tape
- Drawing paper

- Pencil sharpener
- Plastic eraser
- Kneaded eraser

- Eraser in holder
- Mechanical pencil

- PanPastel® artists' pastels
- Applicator

- Colored pencils

Secure the paper securely with masking tape.

Arrange the tablet and paper so that they are directly in front of you.

Methods for Tracing

It is difficult to start drawing while looking at a photo, so in order for you to enjoy the fun of drawing, I will show you two different ways to trace your subject. Use the one that suits you best.
▶ Preliminary sketches are provided for the motifs in this book, so do make use of them.

METHOD 1

Print and transfer a photo of the subject

MATERIALS NEEDED
- Drawing paper
- Pencil
- Masking tape
- Copy paper
- Mechanical pencil
- Kneaded eraser

Turn over the copy paper on which the motif was printed and fill in the area the size of the motif with pencil.

Place a fresh sheet of drawing paper on the table and gently lay the graphite-covered side of the copy paper from step 1 face down on top of it. Secure the papers with masking tape. Using a mechanical pencil, trace the outlines of the motif.

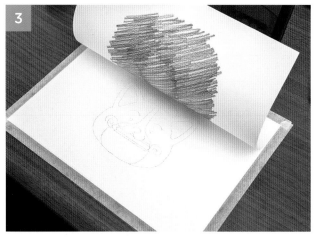

When the paper on top is removed, you will see that the motif has been transferred to the drawing paper.

If the lines appear too dark, tap them with a kneaded eraser to make them lighter.

METHOD 2

Use grid lines as a guide

MATERIALS NEEDED
- Drawing paper
- Ruler
- Mechanical pencil
- Tablet
- Masking tape
- Plastic eraser

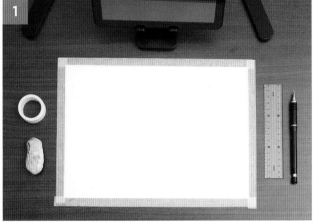

Secure the four sides of the drawing paper with masking tape to prevent it from moving.

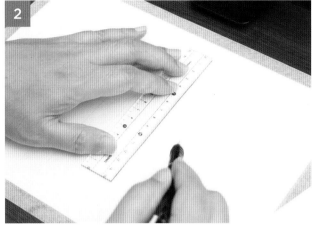

On A4 size paper, draw ¾-in (20-mm) squares. The squares need to be marked out and drawn precisely.

Draw the lines lightly so that they are easy to erase.

Use an app to draw grid lines on top of the motif, and display it on the screen.

Using the grid lines to measure distances, copy the drawing onto the paper.

Once the tracing has been done, erase the grid lines.

ESTIMATED DURATION: 3 HOURS

LEVEL: BEGINNER

Draw an Orange

Our first project is to draw a half of an orange. First, identify the parts that make up the fruit: the white, cottony core, the fresh transparent flesh and the thin membranes containing the juicy segments. It is not difficult to draw each part of the fruit individually. Let us start our realistic drawing lessons.

● SUBJECT PHOTO

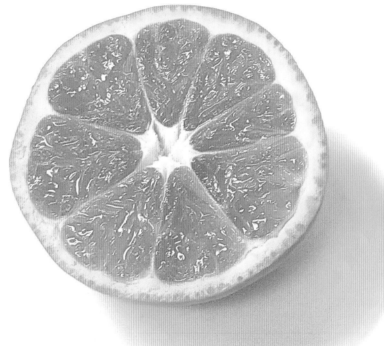

If you have a PC or a tablet, discard the color information of the subject photo and view it once in grayscale.

• •

Color is perceived by the reflection of light. The sharper the light, the more intensely it is seen. If you make the orange monochrome, you can see that the pulp of the orange is glowing. If you can depict this light, you can create a realistic image.

It is not always easy to find the color you want to apply. Mixing two or more colors to create a desired color is called "color mixing."

● SEARCHING FOR COLORS

 The main colors in the photograph are these:

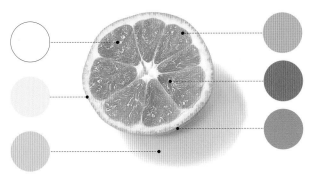

▶ These colors were selected visually. Use them as a reference for your own color search.

COLOR PALETTE (COLORS USED)

● COLORED PENCILS
(Faber Castell Polychromos)

	101 White
	107 Cadmium Yellow
	111 Cadmium Orange
	113 Glazing Orange
	187 Burnt Ochre
	280 Burnt Umber

● PANPASTEL® (Holbein)

	22505 Diarylide Yellow
	22803 Orange Shade
	22805 Orange

★ If using colored pencils instead of PanPastel®

22505←→108 22805←→111
22803←→187

● MATERIALS USED

- Colored pencils (Faber Castell Polychromos)
- PanPastel® artists' pastels (Holbein)
- Kent or Bristol drawing paper
- Tools for line drawing (mechanical pencil, kneaded eraser)
- Le Plume pigment white brush pen OP920 (Marvy Uchida)
- Tissue paper

● STEPS TO COMPLETION

1. Line drawing (page 34) ▶ 2. Peel (page 34) ▶ 3. Pulp (page 36)
▶ 4. Details (page 37) ▶ 5. Shadows (page 38) ▶ 6. Completion (page 39)

● LINE DRAWING

Make an enlarged copy of the line drawing below, and then trace it to use as a reference for your own drawing.

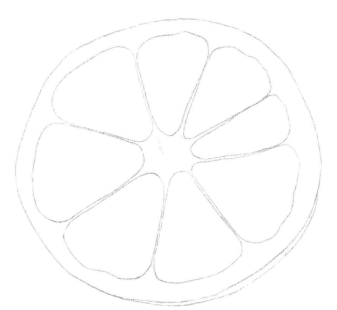

1 Line Drawing (Tracing)

There are many ways to draw a rough sketch. It is difficult to start by simply looking at a photo, so we will practice by tracing. We will show you how to easily trace without drawing grid lines or using a tracing table.

Let us start by tracing.

1

Print the photo you wish to draw on a piece of copy paper, and then turn it right side down and cover the back side with black pencil. It is easier to trace if the pencil is applied thickly.

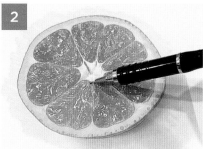

2

Place the photo from step 1 face up on the drawing paper and trace the outline with a mechanical pencil.

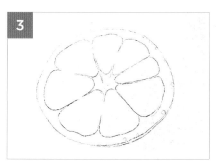

3

Only the traced areas will appear on the drawing paper.

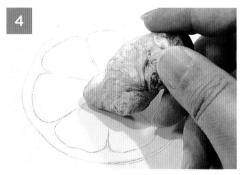

4

To prevent the pencil lines from remaining black when drawn with colored pencils, lighten the lines by dabbing them with a kneaded eraser.

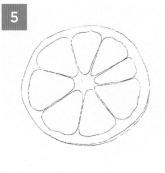

5

The line drawing is complete.

Check!

I have explained how to trace drawings in detail on pages 30 and 31.

2 Color the Peel

Draw the edge of the peel with colored pencil and fill in the area between the skin and the pith (the white part) with PanPastel®. The details of the bumps on the skin are also drawn at this point.

THE COLORS USED AT THIS STAGE

| COLORED PENCIL | 107 | 111 | 187 | PANPASTEL® | 22505 |

Be aware of the thickness of the peel and the roundness of the orange as you apply color.

1

2

● **Apply layers of color to add intensity.**

Instead of applying a thick layer of color all at once, apply the color gradually, checking the shades as you go so that you can adjust the intensity later.

Draw the orange peel with colored pencil No. 111. Draw the part of the peel at the bottom right where the side is slightly thicker.

3

4

5

Apply a base of PanPastel® No. 22505 to the thin inner areas. Apply the color thinly with the tip of the applicator lying on its side.

Apply color over the pastel with colored pencil No. 107 to indicate the thickness of the peel. Use the pencil so that the color is graduated toward the inside of the orange.

6

7

8

Depict the rounded bumps (oil glands) on the peel with colored pencil No. 187.

Apply color on top with colored pencil No. 107 and blend in. If there are areas that are not dark enough, add more color with colored pencil No. 187.

3 Color the Pulp

Using colored pencil No. 111, outline each pulp segment, and then carefully add color while paying attention to the shading. Start by using PanPastel® to apply a thin layer inside the pulp, and then use three different colored pencils to add shading while referring to the photo of the subject.

THE COLORS USED AT THIS STAGE

COLORED PENCIL		107		111		187

PANPASTEL®		22805

Carefully paint the sections one by one.

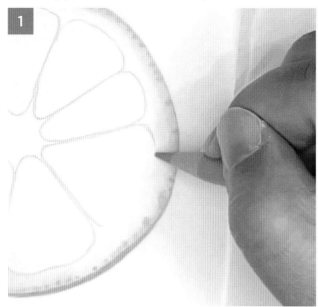

1

Use colored pencil No. 111 to lightly trace the outline of the membrane that surrounds the pulp.

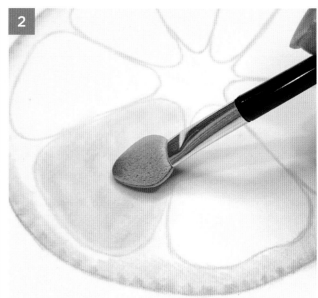

2

Paint the inside with PanPastel® No. 22805. While keeping an eye on the photo of the subject, carefully place the color a little at a time, paying attention to light and dark areas.

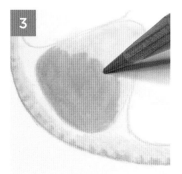

3

Use colored pencil No. 111 to apply color on the entire surface of the pulp segments over the layer of PanPastel®. Create the surface by varying the pencil pressure and being aware of light and dark areas.

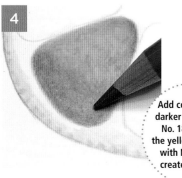

4

Add color to the darker areas with No. 187 and to the yellowish areas with No. 107 to create shading.

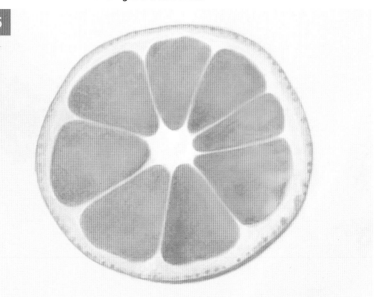

5

● **It is important to observe the photo closely.**

The key point is to add color by moving the colored pencils around to create a surface. If you add color a little at a time to add depth while being aware of shading and details, the transparency of the pulp will be greatly enhanced.

4 Add the Details

Use a white pen to highlight the gloss of the pulp. If you highlight each grain with a curved line while being aware of its roundness, the fruit will have a more three-dimensional appearance. Moreover, by applying details all over the fruit, transparency, depth and three-dimensionality are created.

THE COLORS USED AT THIS STAGE

| COLORED PENCIL | | 101 | | 107 | | 113 | | 187 |

| PANPASTEL® | | 22505 | WHITE PEN | Le Plume Pigment |

Add details to the fruit core, too.

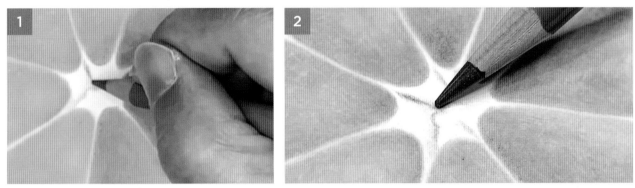

Draw the separations between the fruit segments in the core with colored pencil No. 187. The shadowed parts are blurred toward the outside.

Express the juice vesicle highlights with a white pen.

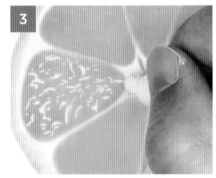

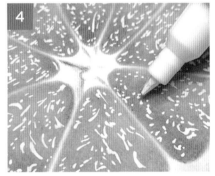

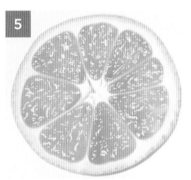

Add highlights with a white pen (Le Plume pigment) while looking at the photo.

Patiently draw the vesicles of the pulp while being aware of their three-dimensionality.

The highlights have been done overall. At this stage they are too strong, so they will have to be adjusted at a later stage.

The juice overflowing and seeping into the rind is also drawn in detail.

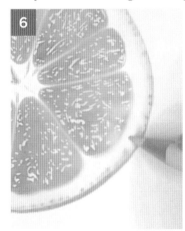

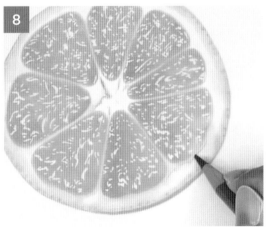

The juice soaks into the white spongy rind between the zest and the pulp, so draw this.

If you add the yellow of the juice with colored pencil No. 107, it will look even more juicy.

The border between the rind and the pulp is drawn in with colored pencil No. 187. While zooming in on the fruit, draw in details, such as scratches and dents.

37

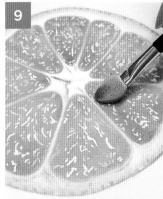

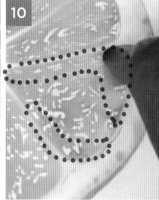

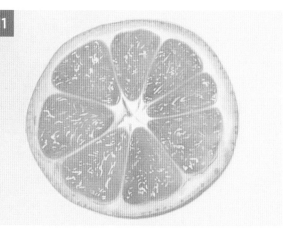

Apply a layer of PanPastel® No. 22505 in some areas where the highlights are too strong to reduce them.

Adding a small layer of PanPastel® to both ends of the segments will make the center of each segment look fuller.

By layering on the PanPastel® the highlights added with the white pen blend in well, and the transparency is enhanced.

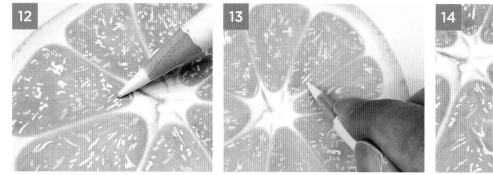

Paint the areas brightened by light with colored pencil No. 101 to lighten the overall color tone.

Colored pencil No. 113 is used to gradually build up the depth of the orange color.

5 Add Shadows

Apply a thin layer of shadow along the curve of the orange, then apply a gradation of shadow, making sure that the shadow becomes darker the closer it is to the orange. Finally, blend the darker and lighter areas of the shadow with a piece of tissue paper.

THE COLORS USED AT THIS STAGE

| COLORED PENCIL | | 187 | | 280 | PANPASTEL® | | 22803 |

The shadows should be graduated from dark to light.

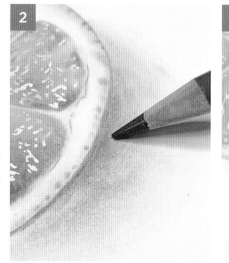

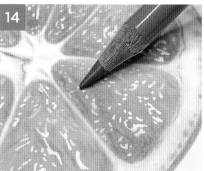

Create a gradation toward the outside while easing the pressure applied to the pencil.

Add a base layer of color with PanPastel® No. 22803. Apply a slightly darker color to the area near the fruit.

Using colored pencil No.187, apply a darker shadow along the curve of the orange.

Darken the area of shadow with colored pencil No. 280.

Layer on PanPastel® No. 22803 and blur and blend in the edges.

Form the tissue into a point and blend the entire surface to create a smooth gradation.

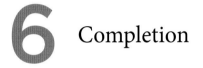

6 Completion

ESTIMATED DURATION: 5 HOURS

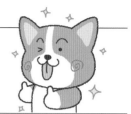

LEVEL: BEGINNER

Draw a Rose

The red of the rose in this photo is not uniform, but changes to various shades of red depending on the color produced by light and shadow. The pleasure of drawing a rose lies in the process of depicting its colors. In this chapter, we will focus on how to express the overlapping of petals as well as the key color application points to create a three-dimensional effect.

● SUBJECT PHOTO

Light

Draw the parts where the light hits with brighter colors.

Draw the parts that are in shadow with darker colors.

Draw each overlapping petal while being aware of the direction of the light.

• •

The rose in this photo is lit from the upper left. Color the light areas brightly and the shadow areas in darker colors. You can succeed if you depict the way the light hits each petal and the shadows created by the overlapping petals.

Red colors vary depending on how light and dark they are.

● SEARCHING FOR COLORS

The main colors in the photograph are these:

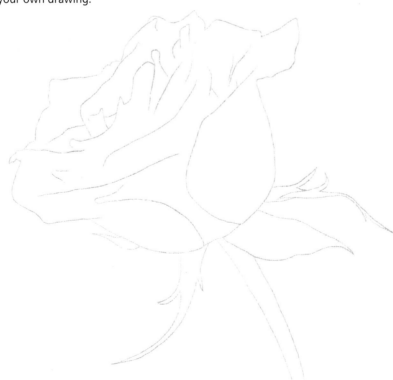

▶ These colors were selected visually. Use them as a reference for your own color search.

COLOR PALETTE (COLORS USED)

● COLORED PENCILS (Faber Castell Polychromos)

117 Light Cadmium Red	192 Indian Red
167 Permanent Green Olive	205 Cadmium Yellow Lemon
168 Earth Yellow Green	219 Deep Scarlet Red
170 May Green	263 Caput Mortuum Violet

● PANPASTEL® (Holbein)

23405 Permanent Red	Bright Yellow Green

★ If using colored pencils instead of PanPastel®

23405←→121 26805←→205

● MATERIALS USED

- Colored pencils (Faber Castell Polychromos)
- PanPastel® artists' pastels (Holbein)
- Kent or Bristol drawing paper
- Tools for line drawing (mechanical pencil, kneaded eraser)

● STEPS TO COMPLETION
1. Outline (page 42) ▶ 2. Petals (page 42) ▶ 3. Calyx and stem (page 47) ▶ 4. Completion (page 47)

● LINE DRAWING

Make an enlarged copy of the line drawing below, and then trace it to use as a reference for your own drawing.

1 Draw the Outline

Start by drawing the outline of the entire flower. To express the delicate thinness of the petals, apply pressure in varying degrees while drawing to increase the three-dimensional effect.

THE COLORS USED AT THIS STAGE

| COLORED PENCIL | ▮ | 219 |

Draw the part where the light hits with thin lines.

❶ Use colored pencil No. 219 to trace a thin line on top of the line drawing.

❷ Draw the parts where the petals overlap each other and are slightly in shadow more strongly.

❸ The outline of the flower parts are completed. At this point, be careful not to draw too much detail, simply reveal the outlines of the petals.

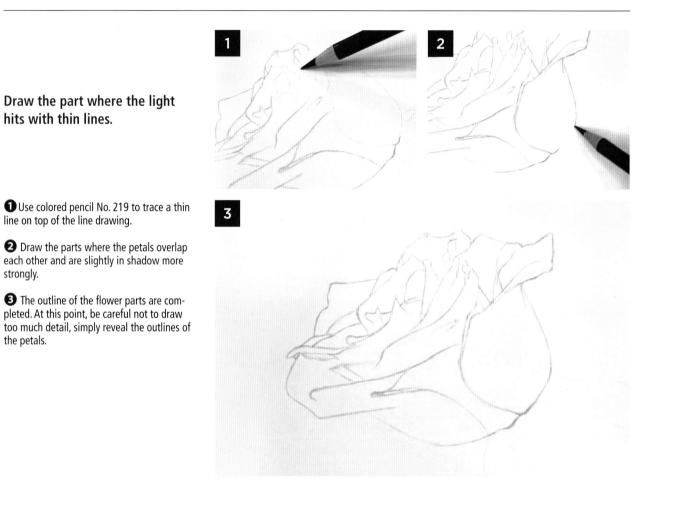

2 Draw the Petals

Apply the lighter colors first, and then gradually add the darker colors. This method allows for easy fine tuning without fear of major color shifts.

THE COLORS USED AT THIS STAGE

| COLORED PENCIL | ▮ | 117 | ▮ | 192 | ▮ | 219 | ▮ | 263 |
| PANPASTEL® | ▮ | 23405 |

Add color to each petal one by one. Start by using PanPastel® No. 23405 to apply a thin base.

3

Add more colors on top of the base coat of PanPastel® with colored pencil No. 219.

4

Apply color to the shadows of the overlapping petals with slightly darker colored pencil No. 192 so that a gradation is created from the bottom.

5

Add another layer of colored pencil No. 219, and apply it in a gradation so that it blends with the darker color.

> The higher up you go, apply the color more thinly. Do not apply color all the way to the border of the petals, leaving the PanPastel® tint visible.

6

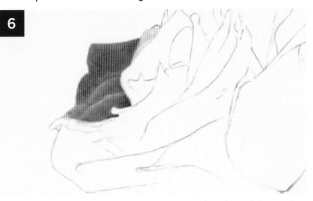

Apply color to the lower petals in the same way. The edges of the petals are left uncolored to bring them into relief.

7

Use PanPastel® No. 23405 to further blend the border area between the petals.

8

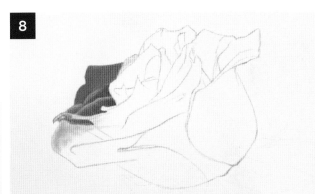

Pause to view the entire image from a distance, and then adjust the colors in areas where they are not natural compared to the photo.

9

Apply color lightly to light areas and more thickly to shadow areas to create a three-dimensional effect.

10

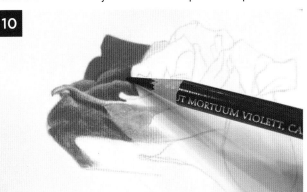

Apply color over areas that are not dark enough with a darker shade of colored pencil No. 263. More layers of the same color can also be used. Apply color to the other petals in the same way.

By repeating the process from darker to lighter colors, a natural gradation of color is created.

While keeping an eye on the overall balance, apply layers of color with colored pencil Nos. 219 and 263, and then blur with PanPastel® No. 23405 to create a natural gradation. Repeat this process to create a three-dimensional flower.

11

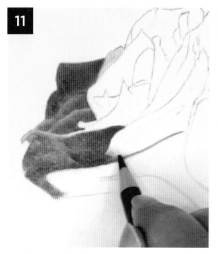

Use deep red for the petal bases.

12

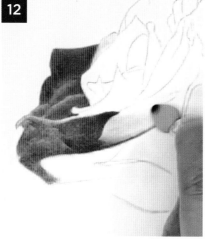

Move the PanPastel® applicator from the darker areas to the lighter areas.

13

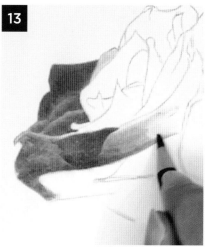

Make the areas lighter where the light hits.

14

Apply color carefully to maintain a clean border between the petals.

15

The smoother the gradations, the more the three-dimensional effect of the petals will stand out.

16

Color should be applied more strongly to the shadow areas.

17

Keep checking the borderlines and textures of the petals during the process.

Even a single petal has many different expressions. Observe the characteristics of each petal before drawing them.

Color should be applied to the edges of the petals in a downward motion, leaving only the thinly applied PanPastel® at the top edges. By adding darker colors to the shadowy areas at the base of the petals, the thin petals achieve a three-dimensional effect.

18

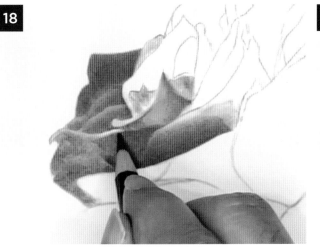

Utilize the white of the paper to highlight the edges of the petals.

19

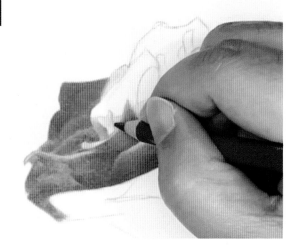

Apply the gradations while identifying where the light is coming from and reflecting it in the drawing.

20

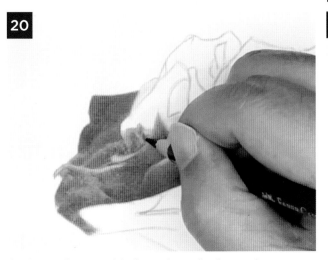

The closer to the center of the flower, the smaller the areas become, so proceed carefully.

21

Apply the PanPastel® base to each petal, one by one.

22

Use different colored pencils, from light red to deep red.

23

Use the sharp point of the colored pencils carefully along the edges of the petals.

How to Create Beautiful Flower Petals

The petals are created by repeating the process of layering colors a little
at a time while shading them with colored pencil Nos. 219, 192 and 263.

Q How do you add warm highlights to the petals?

A The areas that appear slightly orange in the light are tinted with colored pencil No. 117 blended in with the surrounding color.

Q What should I do if I've applied too much color?

A Apply PanPastel® No. 23405 over the areas where you applied color too thickly, and then blend smoothly.

Q What if I want to create deep, rich colors that cannot be depicted with single colored pencils?

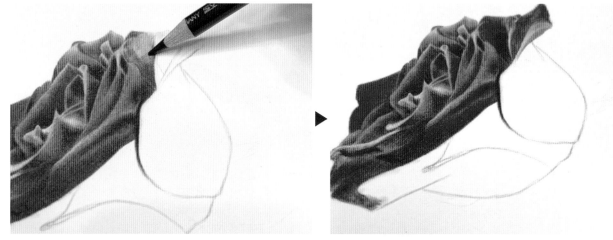

A When drawing in the darkest areas, use colored pencil No. 219, then PanPastel® No. 23405, and then colored pencil No. 219 again. Repeat as needed, applying multiple layers of color while adjusting the saturation with the pressure of the pencil.

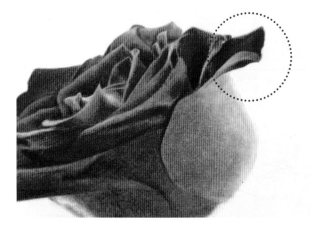

Q How do I draw the fine three-dimensional effects of the petals?

A The edges of the petals should be lightly colored with PanPastel® while leaving the areas where the light hits the petals mostly uncolored.

Apply a gradation of shading from the deepest parts of the petals to the outermost parts, paying close attention to the tonal transition.

By adding darker colors to the shadowy areas within the blossom, the thickness and three-dimensionality of the petals in the foreground are accentuated.

3 Draw the Calyx and the Stem

Extending from the base of the flower is the calyx. This comprises leaf-like structures that are protectively wrapped around the flower when it is in bud form. Knowing this role is important when drawing the calyx.

THE COLORS USED AT THIS STAGE

COLORED PENCIL 167 168 170 205

PANPASTEL® 26805

Draw over the pencil outline of the calyx and stem with colored pencil No. 170.

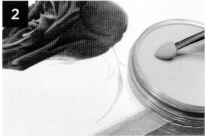

Use colored pencil No. 205 or PanPastel® No. 26805 for the lighter areas.

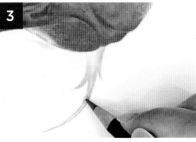

Draw layers of colored pencil No. 168 on the dark areas.

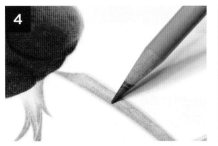

Start coloring the stem from the lighter areas as well. In this case, the light is coming from the back, so make sure both outside edges of the stem show gradation to the brighter green.

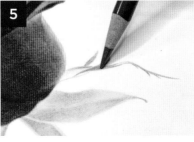

Color the darkest parts of the calyx with colored pencil No. 167.

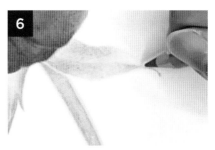

The key point in drawing the wavy shape of the calyx on the right side is to brighten the convex areas illuminated by light and to add a slightly darker color to the concave areas. In this way, the natural undulations are clearly indicated.

4 Completion

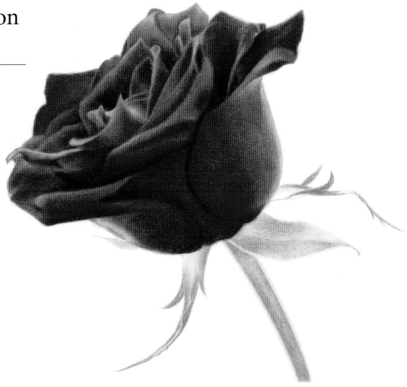

ESTIMATED DURATION: 3 HOURS

LEVEL: BEGINNER

Draw a Marble

Marbles are an easy subject to work with because of their relatively small number of colors. The goal is to depict a sphere and show its transparency. Success is achieved when you can show where the light is shining from and where the shadow is falling.

● SUBJECT PHOTO

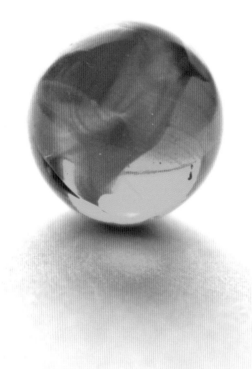

With the sphere in mind, consider the areas in which
to apply the colors and their saturation and lightness.

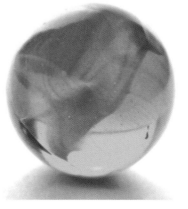

• •

When depicting a glass cup, the background reflected in the glass can be drawn to create a sense of transparency. However, in the case of a marble, it is not the color of the background that is important, but rather the shading and drawing of the pattern visible within the glass that is required to express transparency. First, let us take a look at the subject photo in grayscale. Observe the density of the varying opaque swirls in the marble and the direction of the light.

Try different methods of color mixing before you start drawing.

● SEARCHING FOR COLORS

 The main colors in the photograph are these:

▶ These colors were selected visually. Use them as a reference for your own color search.

● STEPS TO COMPLETION
1. Patterns in the marble (page 50) ▶ 2. Shadow (page 53)
▶ 3. Completion (page 53)

● LINE DRAWING
Make an enlarged copy of the line drawing below, and then trace it to use as a reference for your own drawing.

COLOR PALETTE (COLORS USED)

● COLORED PENCILS
(Faber Castell Polychromos)

	101 White
	110 Phthalo Blue
	141 Delft Blue
	144 Cobalt Blue Green
	151 Helioblue Reddish
	273 Warm Grey IV

● PANPASTEL® (Holbein)

	25205 Ultramarine Blue
	25805 Turquoise
	28205 Neutral Grey

★ If using colored pencils instead of PanPastel®

25205⟷143 28205⟷231
25805⟷145

● MATERIALS USED

- Colored pencils (Faber Castell Polychromos)
- PanPastel® artists' pastels (Holbein)
- Kent or Bristol drawing paper
- Tissue paper
- Tools for line drawing (mechanical pencil, kneaded eraser)

1 Draw the Patterns in the Marble

Colored pencils can be used to create depth of color by applying subtle pressure in multiple layers. By being aware of light and dark, and shades of color, you can depict the transparency of the marble.

THE COLORS USED AT THIS STAGE

| COLORED PENCIL | | 101 | | 110 | | 141 | | 144 | | 151 |
| PANPASTEL® | | 25205 | | 25805 | | | | | | |

The key point is to apply more color on the edges of the sphere and less color on the inside.

1

Trace a thin line on the drawing with colored pencil No. 144.

2

Start coloring at the top of the circular design. Apply the base layer with PanPastel® No. 25205.

3

Start coloring at the top of the circular design. Apply the base layer with PanPastel® No. 25205.

KEY POINT

If you want to make the color darker, apply thin layers in the following order: PanPastel®, colored pencil, PanPastel®, colored pencil and so on. In this way you can easily adjust colors and get closer to your ideal color.

4

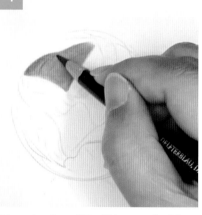

Using colored pencil No. 151, create depth by layering the color while being aware of the colorful structure inside the marble.

5

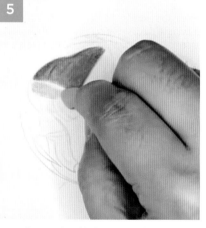

Leave the streaks of light uncolored and apply color in layers with PanPastel® No. 25205 and colored pencil to the adjacent upper left region.

6

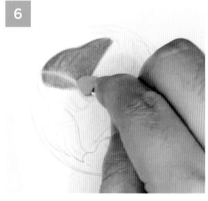

Once the area beneath has been colored, blend in the uncolored streaks of light with PanPastel® No. 25205.

7

8

Continue coloring the other areas in the same way.

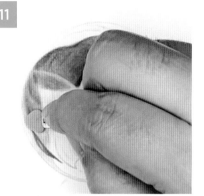

Repeat the process of coloring the base with PanPastel® No. 25205 and drawing in details with colored pencils. By depicting a richly colored form underneath and then layering colors on top, a translucent effect can be achieved.

Because the marble is spherical, applying color while being aware of its roundness as shown in the illustration will greatly enhance its three-dimensionality.

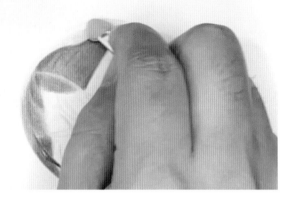

Apply a thin layer of PanPastel® No. 25205 at the top of the marble where the light shines through, and then blend the border with the area below using colored pencil No. 151.

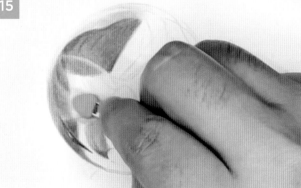

Apply the base color with PanPastel® No. 25205, then layer with colored pencils. Repeat this process.

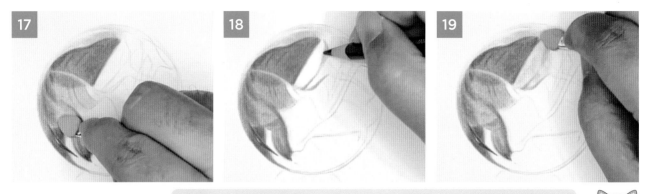

If you have applied colored pencil too strongly, you can make the darker parts appear relatively lighter by applying PanPastel® No. 25805 to adjacent lighter areas, reducing the contrast.

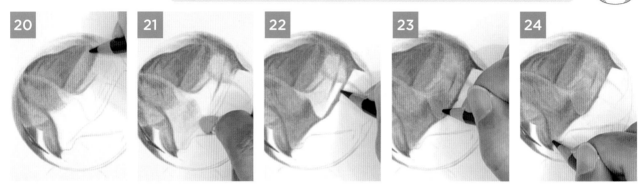

On the bottom where the light penetrates, apply a thin base with PanPastel® No. 25805, and then layer over it with white colored pencil to create a gradient.

Color the light areas with PanPastel® No. 25805 and colored pencil No. 110. Then, add a layer of colored pencil No. 101 to show the light passing through.

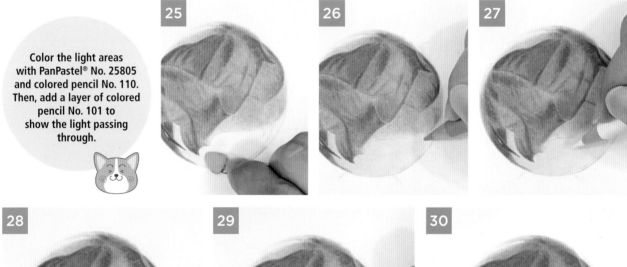

Use colored pencil No. 151 to make the outside edge darker, and then blend the edge to the inside with colored pencil No. 110 by using less pressure.

Apply PanPastel® No. 25805 all over the marble and blend.

Put the finishing touches on the areas that are not dark enough with colored pencil No. 141.

2 Draw the Shadow

The shadow area directly under the marble is the darkest part of the drawing, and the blue color is mixed to create a beautiful gradation. In this way, the color of the marble's shadow enhances the sense of transparency.

THE COLORS USED AT THIS STAGE

COLORED PENCIL		141		273	
PANPASTEL®		25205		25805	28205

The relationship between the direction of the light and the location of the shadow is important.

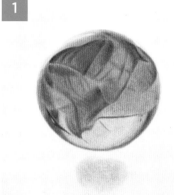

1

Apply the base color. Pat on PanPastel® No. 25805 in the light areas.

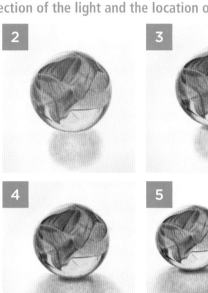

2

3

4

5

❷ Layer PanPastel® No. 25205 on the slightly darker outer areas.

❸ Use colored pencil No. 141 with the addition of PanPastel® No. 25205 for the darkest area where the marble touches the surface beneath it.

❹ Use PanPastel® No. 28205 to make the outer gray shadow. Make the gray lighter as it moves outward. The inner part of the shadow is tinted with blue, and the natural gradient is created using colored pencil No. 27.

❺ Blur the outer edges by rubbing them with tissue paper.

3 Completion

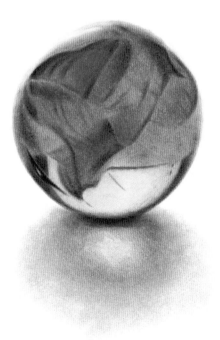

Using Colored Pencils Alone and with PanPastel®

The technique for realistic expression with colored pencils is to apply multiple layers of color to create a three-dimensional effect. The addition of PanPastel® gives a finer grain to the applied pigments than using colored pencils alone, and the resulting colors have more depth. Let us compare drawings of a marble and an apple using only colored pencils with drawings using colored pencils and PanPastel® artists' pastels.

COLORED PENCIL **COLORED PENCIL + PANPASTEL®**

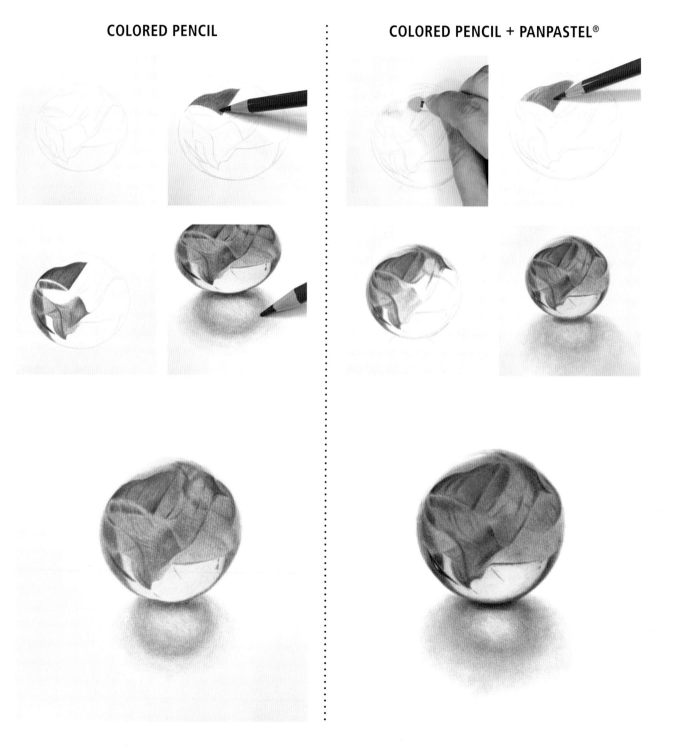

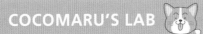
COLORED PENCIL

COLORED PENCIL + PANPASTEL®

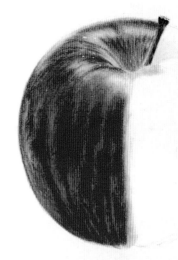

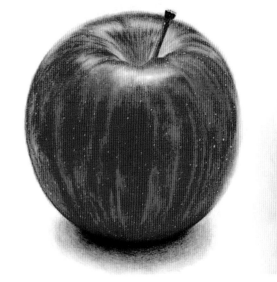

ESTIMATED DURATION: 1 HOUR 30 MINS

LEVEL: BEGINNER

Draw a Spoon

Although it is often thought that drawing a shiny spoon is difficult, it is in fact surprisingly easy to achieve the reflective effect with a small number of colors. Silver colors, such as those of a spoon, are easier to depict than gold. The key is not to color the areas that are exposed to light but to take advantage of the white of the paper.

● **SUBJECT PHOTO**

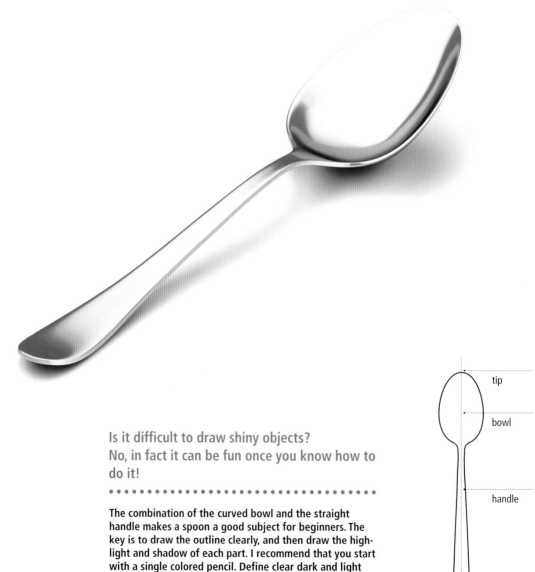

tip

bowl

handle

bottom of handle

Is it difficult to draw shiny objects?
No, in fact it can be fun once you know how to do it!

• •

The combination of the curved bowl and the straight handle makes a spoon a good subject for beginners. The key is to draw the outline clearly, and then draw the high-light and shadow of each part. I recommend that you start with a single colored pencil. Define clear dark and light areas for each part. The areas that are strongly lit, such as the center of the bowl of the spoon, need not be colored at all.

● MATERIALS USED

- Colored pencils (Faber Castell Polychromos)
- PanPastel® artists' pastels (Holbein)
- Kent or Bristol drawing paper
- Tools for line drawing (mechanical pencil, kneaded eraser)

● SEARCHING FOR COLORS

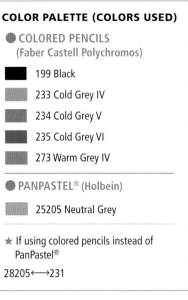

The main colors in the photograph are these:

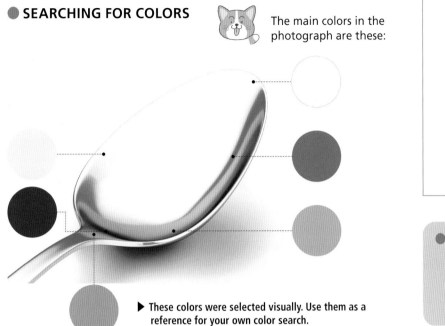

▶ These colors were selected visually. Use them as a reference for your own color search.

COLOR PALETTE (COLORS USED)

● COLORED PENCILS
(Faber Castell Polychromos)

■	199 Black
■	233 Cold Grey IV
■	234 Cold Grey V
■	235 Cold Grey VI
■	273 Warm Grey IV

● PANPASTEL® (Holbein)

■	25205 Neutral Grey

★ If using colored pencils instead of PanPastel®

28205⟵⟶231

● STEPS TO COMPLETION

1. Bottom of handle (page 58)
▶ 2. Handle (page 58) ▶ 3. Bowl (page 58) ▶ 4. Shadow (page 59)
▶ 5. Completion (page 59)

● LINE DRAWING

Make an enlarged copy of the line drawing below, and then trace it to use as a reference for your own drawing.

1 Draw the Bottom of the Handle

A shiny metal spoon is characterized by the subtle surface characteristics of each part. The scooping part of the spoon is called the "bowl," and its depth and smoothness are expressed by the reflection of the surface.

THE COLORS USED AT THIS STAGE

| COLORED PENCIL | | 199 | | 235 | | 273 |
| PANPASTEL® | | 28205 | | | | |

Be mindful of the transitions between curved and flat surfaces as you add color.

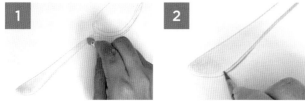

Apply PanPastel® No. 28205 to the bottom of the handle in a fairly thick layer, and then extend the layers to the handle. Next, draw the thickness of the spoon using colored pencil Nos. 273 and 199.

Add shadows with PanPastel® No. 28205, and then draw the darker parts of the shadow using colored pencil No. 199.

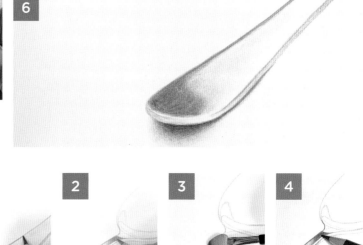

Color the shadow areas of the handle lightly with PanPastel® No. 28205, and then use colored pencil Nos. 273 and 199 to darken it a little at a time. Use colored pencil No. 235 to make the flat part of the handle darker.

2 Draw the Handle

THE COLORS USED AT THIS STAGE

COLORED PENCIL		235
		273
PANPASTEL®		28205

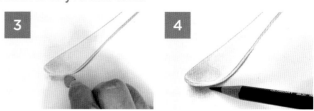

Color the dark area from the bottom of the handle to the bowl. Use colored pencil No. 273 to draw the darker areas of the handle toward the center. Color the narrower part of the handle with PanPastel® No. 28205, and then darken it with colored pencil No. 235.

3 Draw the Bowl

THE COLORS USED AT THIS STAGE

COLORED PENCIL		199
		233
		234
PANPASTEL®		28205

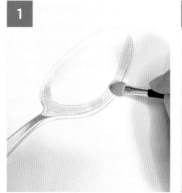
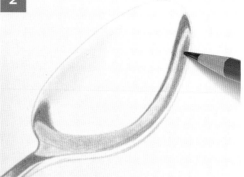

Apply the base color to the colored areas in the subject photo with PanPastel® No. 28205.

Color the darker areas with colored pencil No. 234. Use strong or light pressure to depict the darks and lights.

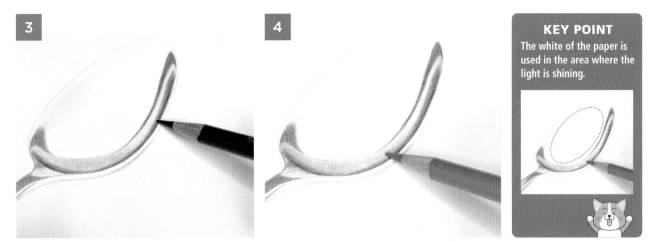

KEY POINT

The white of the paper is used in the area where the light is shining.

Use colored pencil No. 199 in the darker areas to add more contrast, and then colored pencil No. 233 to create a gradation with varying degrees of pencil pressure.

4 Draw the Shadow

THE COLORS USED AT THIS STAGE

| COLORED PENCIL | 199 | 233 |
| PANPASTEL® | 28205 | |

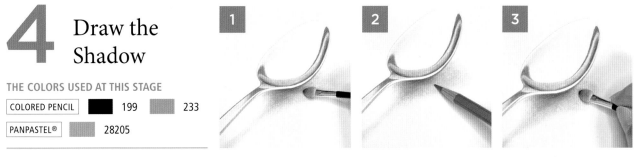

Apply the base color of the spoon's shadow with PanPastel® No. 28205 while referring to the photo. Color in the areas that are not dark enough with colored pencil No. 233. Color the gradient lighter as you move away from the area where the spoon is in contact with the surface. Color the flat surface darker with colored pencil No. 199, and then color over it with No. 233.

5 Completion

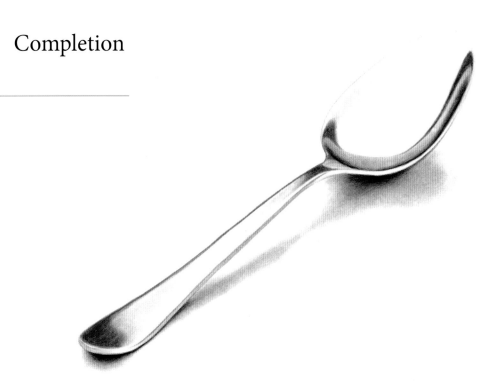

ESTIMATED DURATION: 3 HOURS

LEVEL: INTERMEDIATE

Draw Wine in a Glass

In this chapter, the objective is to depict the transparency of different elements. The first task is to depict the hardness and transparency of a wine glass. The second task is to depict the appearance of a liquid as it is swirled around the glass. Let us challenge ourselves to depict both.

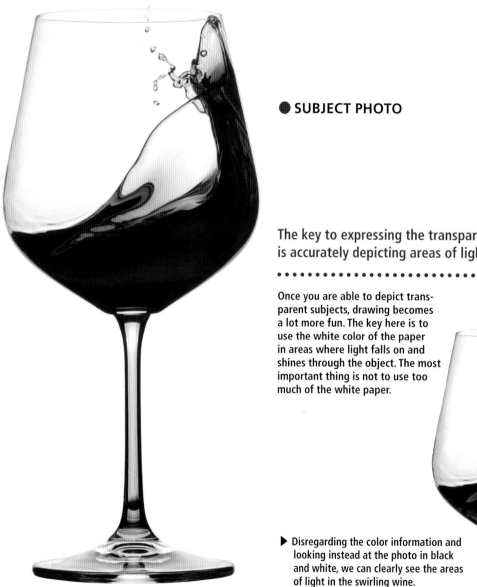

● **SUBJECT PHOTO**

The key to expressing the transparency of a wine glass is accurately depicting areas of light and shadow.

• •

Once you are able to depict transparent subjects, drawing becomes a lot more fun. The key here is to use the white color of the paper in areas where light falls on and shines through the object. The most important thing is not to use too much of the white paper.

▶ Disregarding the color information and looking instead at the photo in black and white, we can clearly see the areas of light in the swirling wine.

● MATERIALS USED

- Colored pencils (Faber Castell Polychromos)
- PanPastel® artists' pastels (Holbein) • Kent or Bristol drawing paper
- Tools for line drawing (mechanical pencil, kneaded eraser)

● SEARCHING FOR COLORS

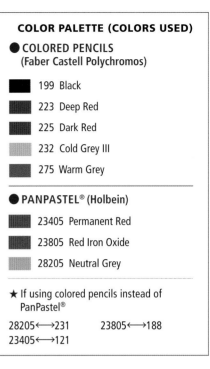

The main colors in the photograph are these:

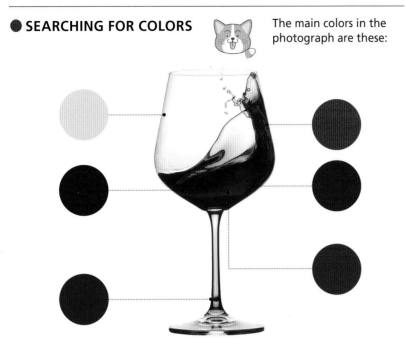

▶ These colors were selected visually. Use them as a reference for your own color search.

COLOR PALETTE (COLORS USED)

● COLORED PENCILS
(Faber Castell Polychromos)

■	199	Black
■	223	Deep Red
■	225	Dark Red
■	232	Cold Grey III
■	275	Warm Grey

● PANPASTEL® (Holbein)

■	23405	Permanent Red
■	23805	Red Iron Oxide
■	28205	Neutral Grey

★ If using colored pencils instead of PanPastel®

28205⟷231 23805⟷188
23405⟷121

● STEPS TO COMPLETION

1. Wine glass (page 62) ▶
2. Outlines of wine (page 65) ▶
3. Color the wine (page 66) ▶
4. Add depth (page 68) ▶
5. Completion (page 69)

● LINE DRAWING

Make an enlarged copy of the line drawing below, and then trace it to use as a reference for your own drawing.

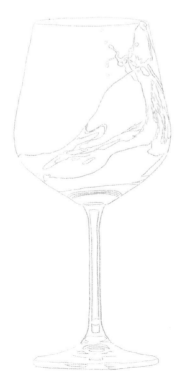

1 Draw the Wine Glass

A wine glass becomes more realistic when elements such as the beauty of the form, the reflection and the thinness of the glass are depicted as accurately as possible. First, let us divide the wine glass into its parts.

THE COLORS USED AT THIS STAGE

| COLORED PENCIL | ■ 199 | ▨ 232 | ■ 225 | ■ 275 |
| PANPASTEL® | ▨ 28205 |

When drawing a curve, pay attention to the angle of your wrist.

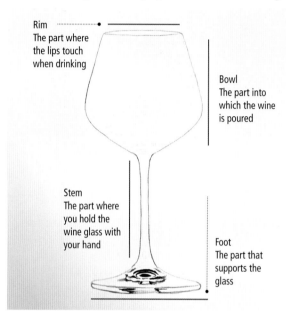

Rim
The part where the lips touch when drinking

Bowl
The part into which the wine is poured

Stem
The part where you hold the wine glass with your hand

Foot
The part that supports the glass

The names of the wine glass components
The rounded body of a wine glass is called the "bowl," the stem is the leg that serves as the handle, and the base that supports the glass is called the "foot." The reflections of each part should be clearly depicted.

Trace the outline of the glass on top of the line drawing using colored pencil No. 275. Note the curve of the bowl, and draw the stem and the foot. Be careful not to make the lines too dark.

1

When drawing the curves of the bowl, relax your hand and use a smooth turn of the wrist to trace the line drawing and create a smooth curve.

2

To draw the top of the glass, tilt your wrist upward and trace.

3

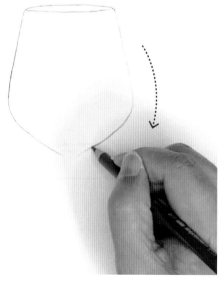

As in step 1, draw the curve on the right side of the bowl.

4

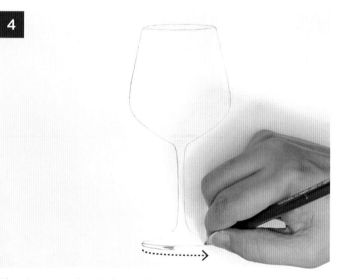

When drawing the foot, the base of the glass, tilt your wrist downward and trace.

Draw the reflection of the foot and stem.

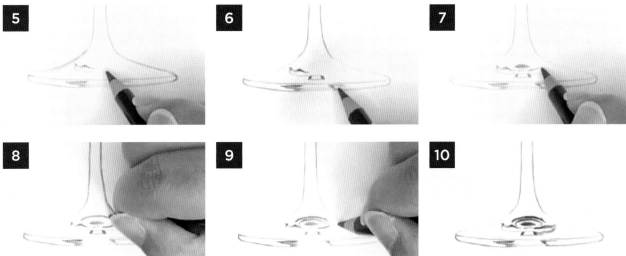

Draw the pattern of the reflection on the foot using colored pencil No. 275. Carefully draw in the details by enlarging the subject photo.
If you look closely, you will see the stem is partly reflected on the foot.

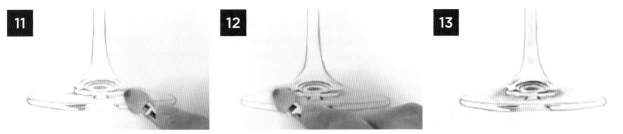

Use PanPastel® No. 28205 to blend the blurred areas of the reflection. The key is not to apply the pastel to the entire foot, but to create a gradient that quickly softens as it extends outward.

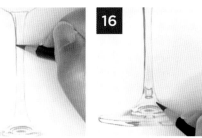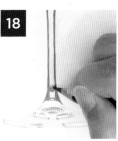

For the stem, use PanPastel® No. 28205 and apply the color as thinly as possible, keeping in mind the straight lines.

Color the darker areas with colored pencil No. 199. Because the stem has dark shadows on the left and right sides, color the shadows crisply so as not to spoil the beauty of the delicate stem.

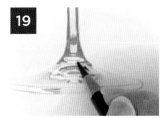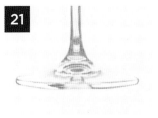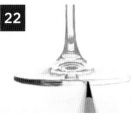

Continue to draw the detailed patterns in the darker areas.

Color the thicker part of the foot with colored pencil No. 199.

For small areas, it is best to fill in the area inside after defining the outline so that there is less chance of making a mistake.

Finish the stem and the foot.

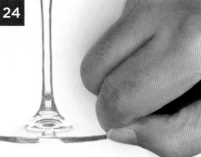

Darken the darker areas of the stem and foot with black colored pencil No. 199.

Finish the stem and foot. Draw both using colored pencil No. 232, adjusting the color saturation as you go along. Keep in mind the transparency of the glass and be careful not to apply too much color.

Add shadows and roundness to the bowl.

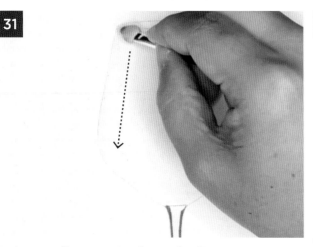

Apply PanPastel® No. 28205 in a downward stroking motion.

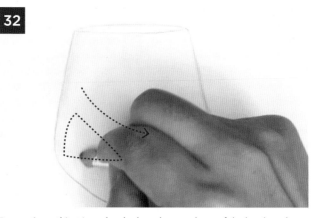

By creating a thin triangular shadow, the roundness of the bowl can be expressed. Apply a slightly darker layer of PanPastel® No. 28205 to the left side of the bowl and extend it in the direction of the arrow.

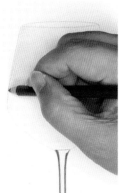

33

To depict the reflection of the red color of the wine on the left side of the bowl, add a thin layer of color with colored pencil No. 225.

34

Use colored pencil No. 199 to slightly sharpen the outline of the bowl and tighten the lines.

35

Use an eraser in a holder to erase any PanPastel® that is outside the lines.

36

Gently brush away any eraser debris, and the glass is done.

2 Draw the Outlines of the Wine

Draw the outlines of the wine as it swirls in the glass. The smoothness of the liquid's curves and the shape of the reflection form the basis of the wine's unique color and transparency.

THE COLORS USED AT THIS STAGE

| COLORED PENCIL | | 275 |

Make the lines bold when drawing the surface of the wine.

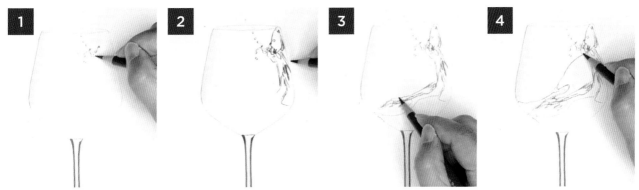

1 **2** **3** **4**

Trace the outline of the liquid on the line drawing with colored pencil No. 275. Use fairly strong pressure.

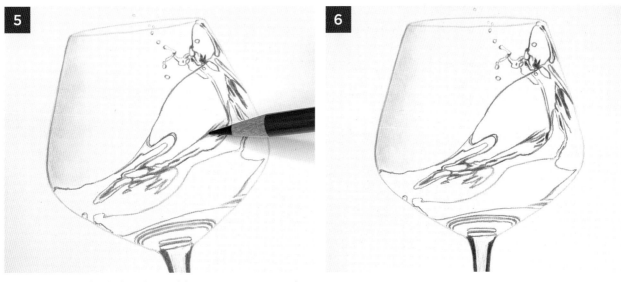

5 **6**

Draw the outline in the shadowed area of the wine even more strongly.

3 Color the Wine

After outlining the wine, apply the base first with PanPastel® 23805. Do not color the entire surface uniformly. The darker areas should be colored darker and the application should follow the same direction that the wine swirls.

THE COLORS USED AT THIS STAGE

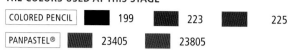

| COLORED PENCIL | ■ | 199 | ■ | 223 | ■ | 225 |
| PANPASTEL® | ■ | 23405 | ■ | 23805 | | |

The liquidity and transparency of the wine is created by drawing it in the glass.

1
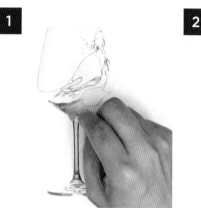

2

3
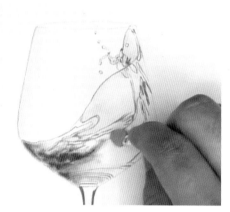

Start applying color from the bottom of the glass with PanPastel® No. 23805, coloring from the bottom to the top in the same direction that the wine moves.

Keep on coloring while being aware of shading.

4

5
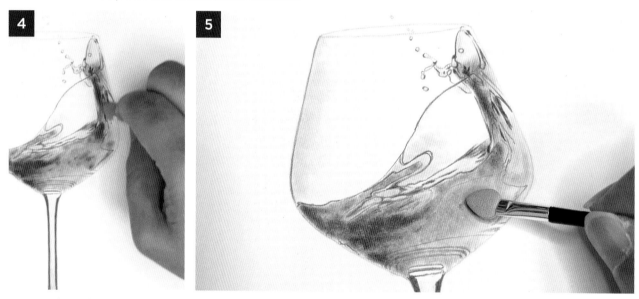

Put more color on the darker areas and extend the PanPastel® in the direction of the movement of the wine, in this case the upper right.

6

7

8
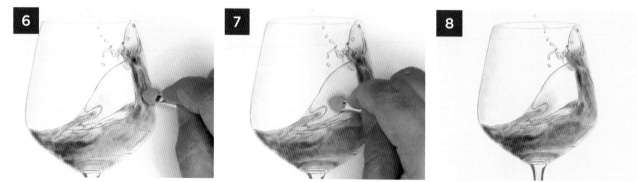

Add more layers of PanPastel® No. 23405 to add depth to the wine color. By layering PanPastel® No. 23405 with varying degrees of intensity, complex variations in shade are created.

66

9

10

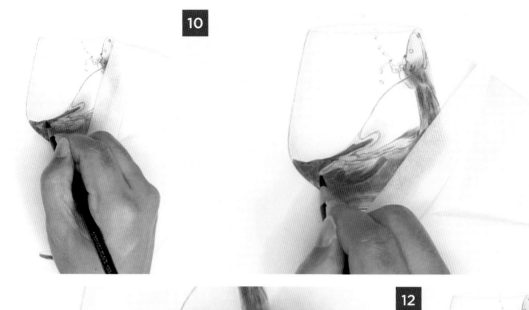

11

12

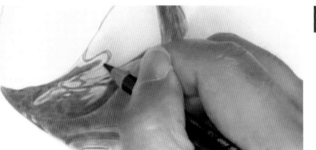

Color in the shadow of the liquid with colored pencil No. 199. Using the previously drawn outline as a guide, use strong pressure to draw the shadow.

13

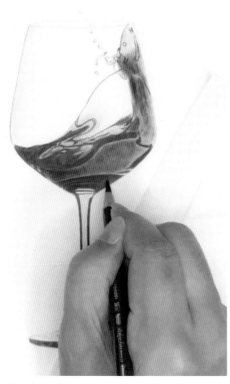

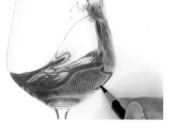

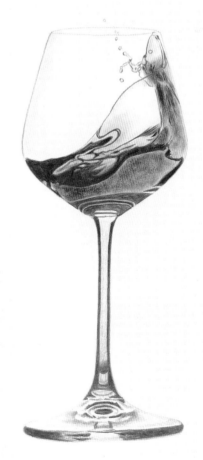

Add a layer of colored pencil Nos. 225 and 223 on top of the darkly colored area, and then another layer of colored pencil No. 199 on top of the area where the bowl and stem join.

One point of advice for applying color

For filling large areas, outline the area and then fill in the middle to get the best results.

4 Add Depth

Add depth to the color of the wine. Layer on more color to depict the black-tinged reds of the wine.

THE COLORS USED AT THIS STAGE

| COLORED PENCIL | 199 | 223 | 225 |
| PANPASTEL® | 23405 | 23805 | |

1

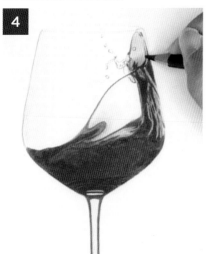

Use colored pencil No. 199 to make the light and dark areas more distinct.

2

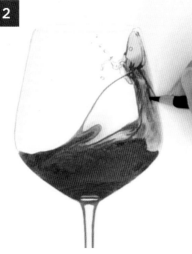

Clearly define the wavy details of the wine.

3

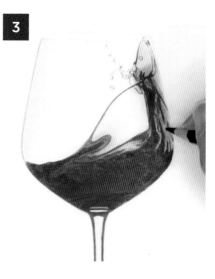

4

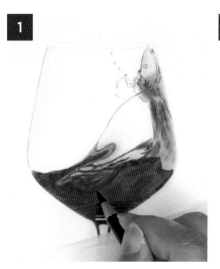

You can now clearly see the dynamic movement of the wine.

5

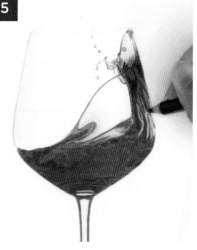

Use colored pencil Nos. 225 and 223 to achieve an even more realistic wine color.

6

Layer on colored pencil No. 199.

7

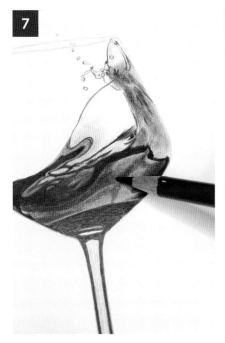

Lay colored pencil No. 223 on top. By doing this, a darker red color will be depicted, which will enhance the wine's liquid quality.

8

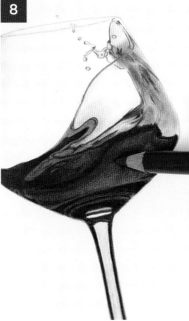

Use colored pencil Nos. 223 and 225 to draw the wave pattern of the wine.

9

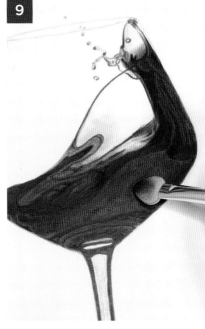

Layer on PanPastel® Nos. 23805 and 23405. If the layered areas are too light, adjust the density with colored pencil No. 199.

5 Completion

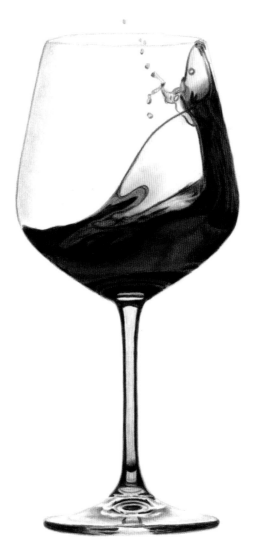

ESTIMATED DURATION: 6 HOURS

LEVEL: INTERMEDIATE
Draw a Rhinoceros Beetle

Although it may appear that a rhinoceros beetle is completely black, there are in fact many colors hidden in it. Moreover, the three-dimensionality of the beetle changes dramatically depending on whether you add shadows or not. Enjoy the transformation as you draw.

● **SUBJECT PHOTO**

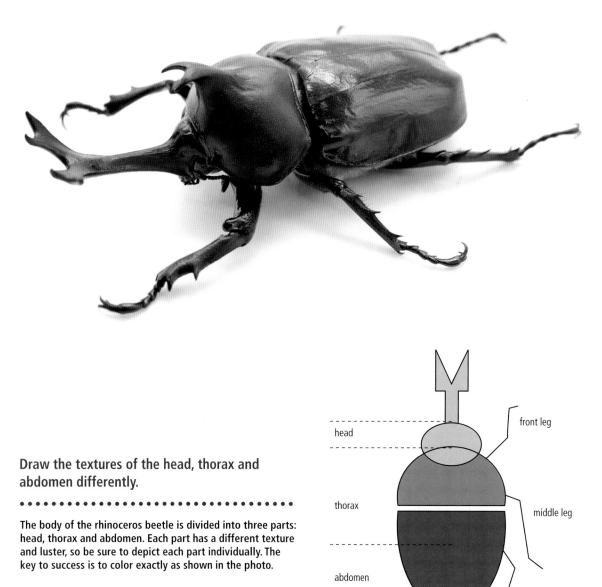

Draw the textures of the head, thorax and abdomen differently.

• •

The body of the rhinoceros beetle is divided into three parts: head, thorax and abdomen. Each part has a different texture and luster, so be sure to depict each part individually. The key to success is to color exactly as shown in the photo.

Although it may not look like there is much color in a rhinoceros beetle, a closer look reveals unexpected hues.

● SEARCHING FOR COLORS

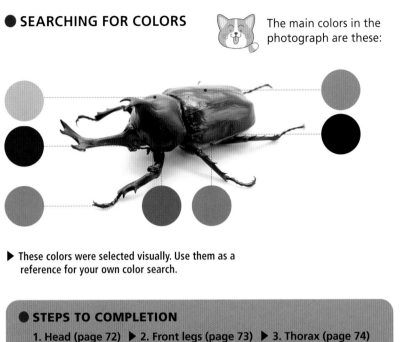

The main colors in the photograph are these:

▶ These colors were selected visually. Use them as a reference for your own color search.

COLOR PALETTE (COLORS USED)

● COLORED PENCILS
(Faber Castell Polychromos)

	181 Payne's Grey
	182 Brown Ochre
	186 Terracotta
	199 Black
	280 Burnt Umber
	283 Burnt Sienna

● PANPASTEL® (Holbein)

	23803 Red Iron Oxide Shade
	27403 Burnt Sienna Shade
	28005 Black

★ If using colored pencils instead of PanPastel®

23803 ←→ 192 27403 ←→ 283
28005 ←→ 199

● STEPS TO COMPLETION

1. Head (page 72) ▶ 2. Front legs (page 73) ▶ 3. Thorax (page 74)
▶ 4. Middle and back legs (page 75) ▶ 5. Abdomen (page 75)
▶ 6. Shadows (page 77) ▶ 7. Completion (page 77)

● MATERIALS USED

• Colored pencils (Faber Castell Polychromos)
• PanPastel® artists' pastels (Holbein)
• Kent or Bristol drawing paper
• Tools for line drawing (mechanical pencil, kneaded eraser)

● LINE DRAWING

Make an enlarged copy of the line drawing below, and then trace it to use as a reference for your own drawing.

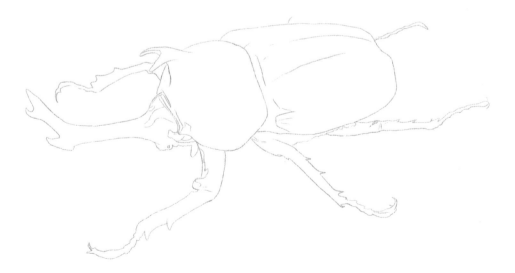

1 Draw the Head

The key to depicting the unique luster of the beetle is to apply the colors in turn strongly and lightly, differentiating between them. Be mindful of thick and thin color application in the small spaces.

THE COLORS USED AT THIS STAGE

| COLORED PENCIL | ▇ 186 | ■ 199 | PANPASTEL® | ■ 28005 |

The hard, glossy luster unique to the rhinoceros beetle can be expressed by drawing highlights and darker areas layered over them.

1

2

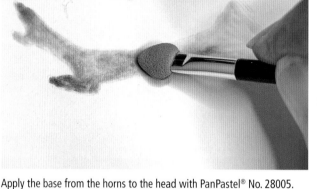
3

Apply the base from the horns to the head with PanPastel® No. 28005.

4

5

6

7

8

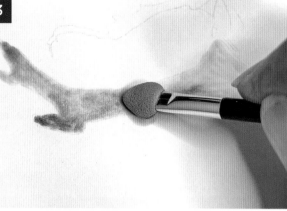
9

After applying the base, color from the outside with colored pencil No. 199 as if drawing an outline.

Pay attention to the line drawing and look carefully at the photograph as you draw the lines with colored pencil No. 199.

10

11

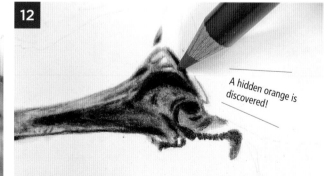
12

A hidden orange is discovered!

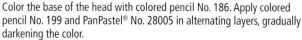

Color the base of the head with colored pencil No. 186. Apply colored pencil No. 199 and PanPastel® No. 28005 in alternating layers, gradually darkening the color.

2 Draw the Front Legs

The thin legs are uneven and have small protrusions. To capture the smallest details, sharpen your colored pencils before you start. Lightly color the areas that are lit and darken the areas that are in shadow.

THE COLORS USED AT THIS STAGE

| COLORED PENCIL | ■ 199 | ■ 283 | PANPASTEL® | ■ 28005 |

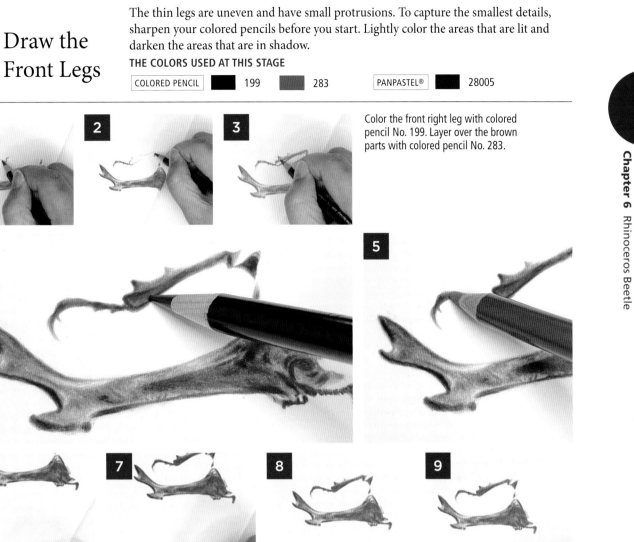

Color the front right leg with colored pencil No. 199. Layer over the brown parts with colored pencil No. 283.

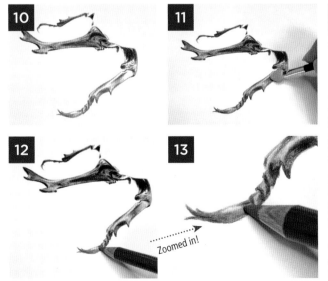

The left front leg is drawn in the same way, shading from the tip with colored pencil No. 199.

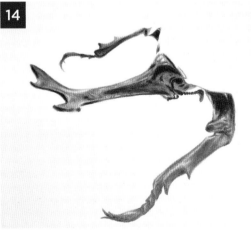

Zoomed in!

Gradually darken the color by alternating layers of colored pencil No. 199 and PanPastel® No. 28005. Add color to the brown areas with colored pencil No. 283.

3 Draw the Thorax

If you zoom in on the photo and observe it closely, you will see that the thorax has a bumpy texture. You should therefore draw the thorax as if it were a collection of dots. The light parts should make use of the white color of the paper.

THE COLORS USED AT THIS STAGE

| COLORED PENCIL | 181 | 199 | 280 |
| PANPASTEL® | 23803 | 27403 | 28005 |

The textured glossy surface is depicted by tapping the colors on the paper.

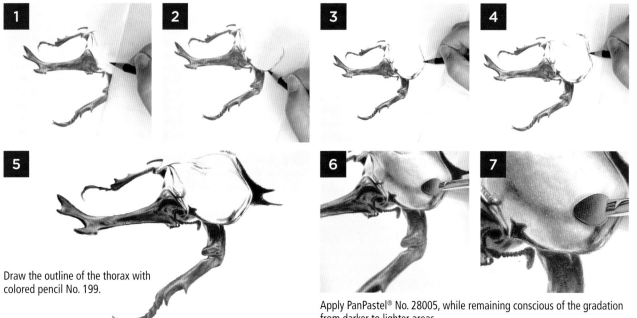

Draw the outline of the thorax with colored pencil No. 199.

Apply PanPastel® No. 28005, while remaining conscious of the gradation from darker to lighter areas.

Leave small areas of the white of the paper.

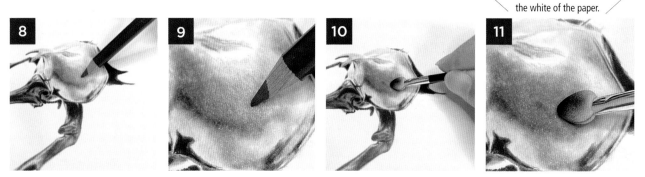

Color the areas that look brown with colored pencil No. 280, and then apply PanPastel® No. 27403 on top of the brown areas with a tapping motion, followed by a layer of PanPastel® No. 23803.

To create a unique texture, use colored pencil Nos. 199 and 181 interchangeably to draw the mottling. Layer on PanPastel® No. 28005 as you work with the colored pencils, and darken the area a little at a time.

4 Draw the Middle and Back Legs

There are complex details on these legs. As with the front legs, color them with a sharpened pencil. If you find it difficult to start from the base, color the edges first.

THE COLORS USED AT THIS STAGE

| COLORED PENCIL | ■ | 199 |

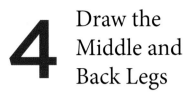

As in the previous section, observe the shapes carefully and draw the darker and lighter areas with colored pencil No. 199.

5 How to Draw the Abdomen

The abdomen has fine details. Because it is difficult to see the line drawing if the base is applied first, roughly outline the abdomen with colored pencils before coloring in the base.

THE COLORS USED AT THIS STAGE

| COLORED PENCIL | ▨ | 182 | ■ | 199 | ▨ | 280 |
| PANPASTEL® | ▨ | 27403 | ■ | 28005 |

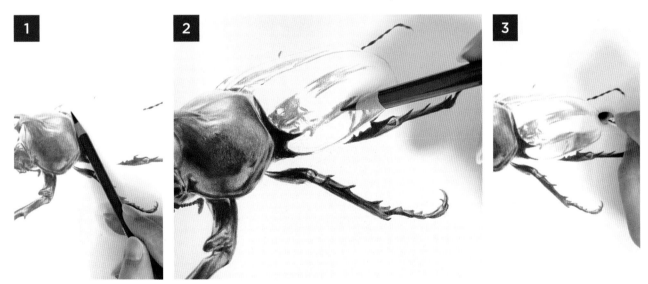

Use colored pencil No. 280 to draw the outline and darker areas toward the back end, and then use PanPastel® No. 27403 to apply the base color on the brown areas.

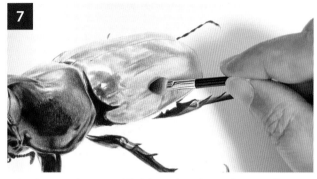

Apply shading on the base. Lightly color the shiny top part.

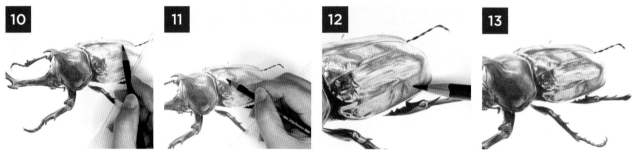

Color the areas that appear black by applying layers of PanPastel® No. 28005.

Draw in the areas that appear darker with colored pencil Nos. 280 and 199.

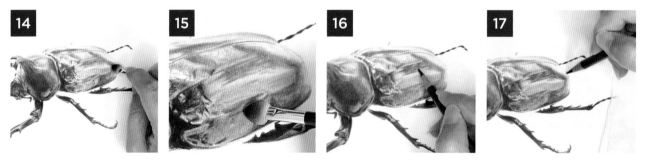

By drawing the small details well, you will clearly depict the texture of the beetle's abdomen.

Use PanPastel® Nos. 28005 and 27403 on top to darken the sides of the abdomen. Apply color to the area with a tapping motion to make it thicker.

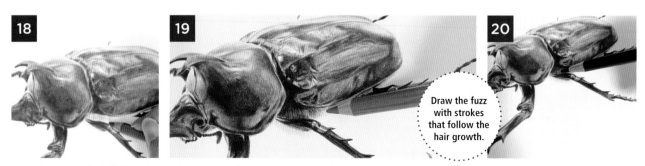

Draw the fuzz
with strokes
that follow the
hair growth.

Draw the fuzz on the belly from the inside to the outside using colored pencil No. 182. Because this will be the shadowed part of the body, add a layer of colored pencil No. 199 to slightly reduce the intensity of the color.

6 Draw the Shadows

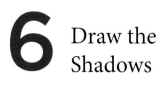

The shadows are key to ultimately achieving the drawing's sense of realism. The shadows where the beetle contacts the surface should be darker, as in the case of the feet, while the shadows at a distance should be lighter. The moment the shadow is applied, the beetle springs into three-dimensional life!

THE COLORS USED AT THIS STAGE

| COLORED PENCIL | ■ 199 | PANPASTEL® | ■ 28005 |

Shadows are important to dramatically increase the presence of the beetle.

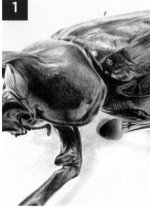

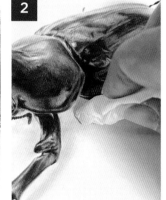

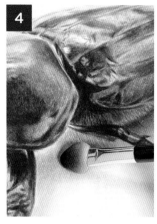

Apply a thin layer of PanPastel® No. 28005 to the shadow under the beetle. If it is not dark enough, apply several layers.

Blur the shadows with a tissue. You can also use a cotton swab.

Use colored pencil No. 199 to add density to the areas where the shadows appear darker.

Gently apply PanPastel® No. 28005 over all of the shadow areas and blend it in.

7 Completion

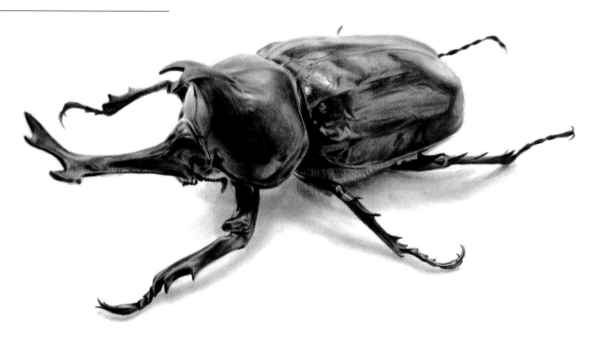

ESTIMATED DURATION: 4 HOURS

LEVEL: INTERMEDIATE

Draw a Parakeet

The colorful feathers of the parakeet and its traditional bird form make it easy to draw. By focusing on the characteristics of the bird, such as the shape of its head and body, and the differences in the texture of the feathers on various parts of the body, you will be able meet the challenge of depicting this subject. Note that parakeets have four "toes" on each foot, two pointing forward and two backward to allow for a strong grip.

● **SUBJECT PHOTO**

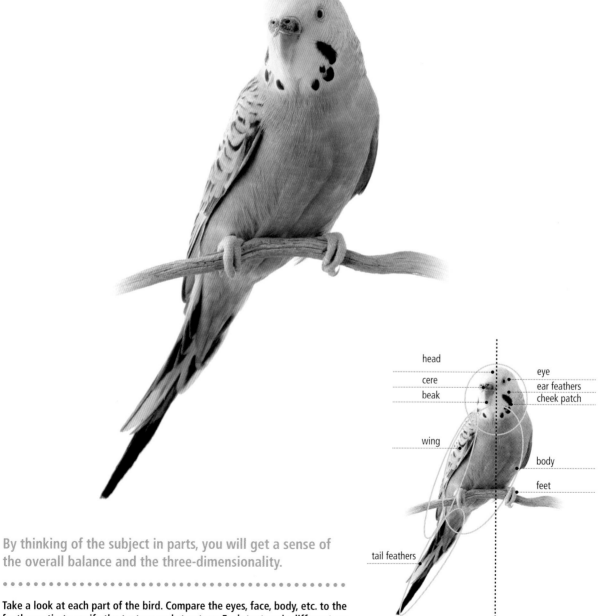

By thinking of the subject in parts, you will get a sense of the overall balance and the three-dimensionality.

head
cere
beak
eye
ear feathers
cheek patch
wing
body
feet
tail feathers

Take a look at each part of the bird. Compare the eyes, face, body, etc. to the feather ratio to verify the texture and structure. Each texture is different, so they must be drawn to reflect this.

● SEARCHING FOR COLORS

The main colors in the photograph are these:

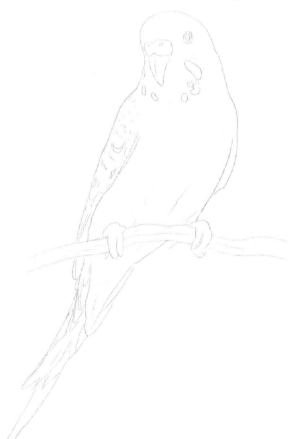

▶ These colors were selected visually. Use them as a reference for your own color search.

COLOR PALETTE (COLORS USED)

● COLORED PENCILS (Faber Castell Polychromos)

105	Light Cadmium Yellow	199	Black
167	Permanent Green Olive	205	Cadmium Yellow Lemon
170	May Green	271	Warm Grey II
172	Earth Green	273	Warm Grey IV
176	Van Dyck Brown	278	Chrome Oxide Green

● PANPASTEL® (Holbein)

22205	Hansa Yellow	27408	Burnt Sienna Tint
26805	Bright Yellow Green	27805	Raw Umber

★ If using colored pencils instead of PanPastel®

| 22205←→105 | 26805←→205 | 27408←→132 | 27805←→178 |

● MATERIALS USED

• Colored pencils (Faber Castell Polychromos)
• PanPastel® artists' pastels (Holbein) • Kent or Bristol drawing paper
• Tools for line drawing (mechanical pencil, kneaded eraser)

● STEPS TO COMPLETION

1. Face and head (page 80) ▶ 2. Body (page 81) ▶ 3. Wings (page 83) ▶
4. Tail feathers (page 84) ▶ 5. Feet and branch (page 85) ▶ 6. Completion (page 85)

● LINE DRAWING
Make an enlarged copy of the line drawing below, and then trace it to use as a reference for your own drawing.

1 Draw the Face and Head

The head is a collection of small parts, so use sharp colored pencils to draw it. The feathers grow out from the body, so draw them in the same direction.

THE COLORS USED AT THIS STAGE

COLORED PENCIL		105		172		176		199		273
PANPASTEL®		22205		27805						

Head and eye

Color the head and face with PanPastel® No. 22205, following the flow of the feathers.

Draw the center of the black eye with colored pencil No. 199. Draw the area around the black eye with colored pencil No. 273, using light pencil pressure.

Cere (the bulbous area above the beak)

Draw the cere above the beak with colored pencil No. 176, shading the color as you go along. Apply PanPastel® No. 27805 on top for a more natural look.

After drawing the beak, add shading with colored pencil No. 176 to finish.

Beak

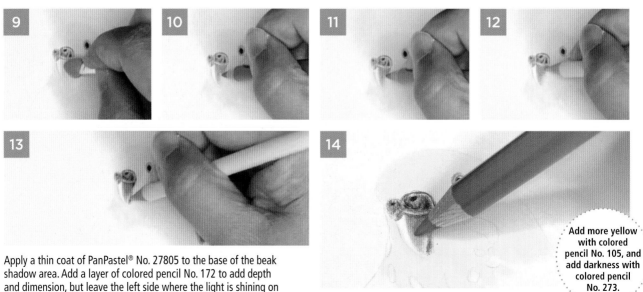

Apply a thin coat of PanPastel® No. 27805 to the base of the beak shadow area. Add a layer of colored pencil No. 172 to add depth and dimension, but leave the left side where the light is shining on it uncolored, so as to make use of the white of the paper.

Add more yellow with colored pencil No. 105, and add darkness with colored pencil No. 273.

Face and head

15
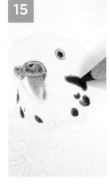

Draw the patterns on the cheek patches using colored pencil No. 199.

16

While zooming in on the photo of the subject, fill in the darker yellow areas with colored pencil No. 105.

17

Lightly draw the strands of the ear feathers with colored pencil No. 273.

18
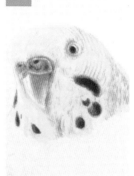

19
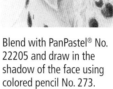

Blend with PanPastel® No. 22205 and draw in the shadow of the face using colored pencil No. 273.

20

The face and head are complete.

2 Draw the Body

When drawing the body of the bird, pay attention to the pose. Also be aware of the flow of the feathers and the light and dark colors.

THE COLORS USED AT THIS STAGE

| COLORED PENCIL | | 167 | | 170 | | 199 | | 278 |
| PANPASTEL® | | 22205 | | | | | | |

Carefully indicate green feathers on the yellow base.

1

2

3

Following the line drawing, apply the base color to the body with PanPastel® No. 22205.

4

5

6

7

8

9

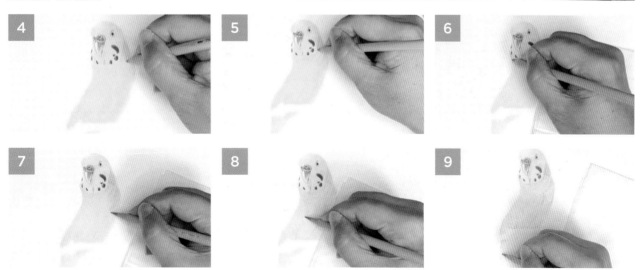

Carefully draw the strands of the feathers, one by one, with colored pencil No. 170, while carefully observing the subject photo.

10

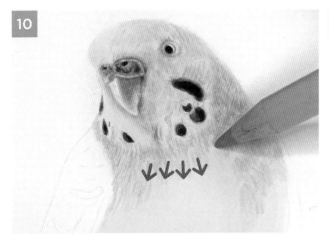

Draw the feathers, one by one, in the direction in which they grow.

11

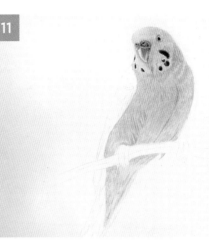

The rough body coloring is now complete.

12

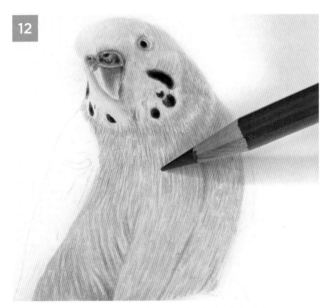

Use colored pencil No. 167 to add areas that look a little darker.

13

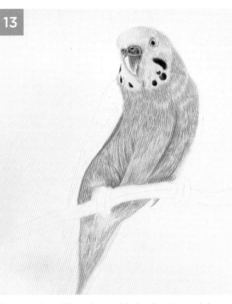

Compare the subject photo with the drawing and draw as accurately as possible. The roundness of the body is expressed by the feathers.

14

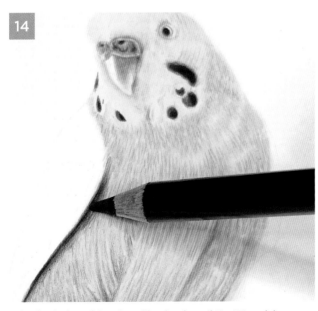

Color the shadow of the wing with colored pencil No. 199, and then go over it with colored pencil No. 167 to blend it with the edge of the body.

15

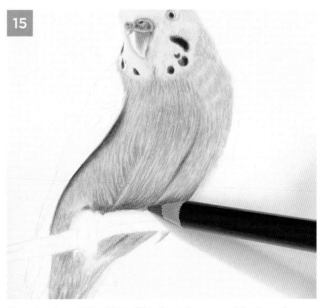

Use colored pencil No. 278 to fill in the darker areas of the flow of feathers.

3 Draw the Wings

The key is to separate the textures of the body and wings. By patiently drawing the details of the patterns and textures of the wings, a realistic view will emerge.

THE COLORS USED AT THIS STAGE

| COLORED PENCIL | | 170 | | 172 | | 199 | | 278 |

| PANPASTEL® | | 26805 |

Differentiate the textures of the body and wings.

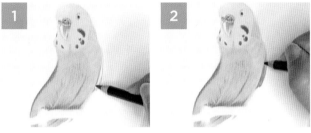

The wing on the right side is in shadow, so apply the base with darker colored pencil No. 278, and then color over it with colored pencil No. 170.

For the wing on the left side, apply the base with PanPastel® No. 26805, and then draw the feather pattern with colored pencil No. 199.

Carefully looking at the subject photo, draw the pattern with colored pencil No. 199. Add the thin lines of the feathers with colored pencil No. 172.

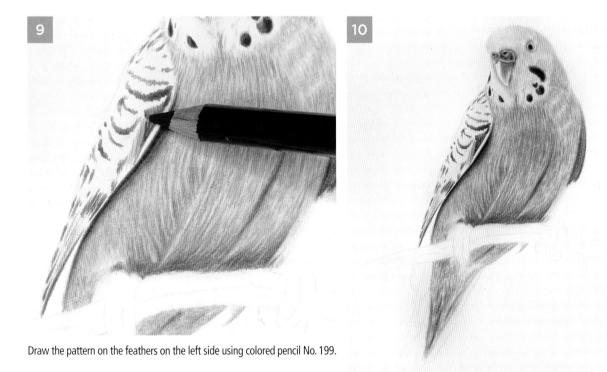

Draw the pattern on the feathers on the left side using colored pencil No. 199.

4 Draw the Tail Feathers

The tail, where several feathers overlap, has a distinct color contrast. The areas where the feathers overlap are also shaded with approximate colors.

THE COLORS USED AT THIS STAGE

| COLORED PENCIL | 170 | 176 | 199 | 205 | 271 |

| PANPASTEL® | 26805 |

Apply layers of color to express the tone and texture of the tail feathers.

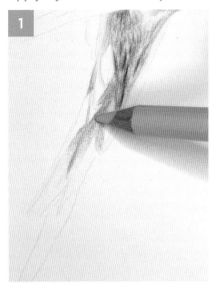

Draw a slightly darker area with colored pencil No. 170, and then fill in the lighter areas around it with colored pencil No. 205.

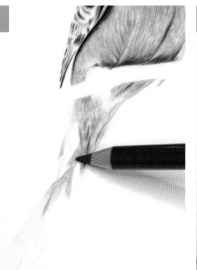

Use colored pencil No. 176 to color in the slightly shaded areas.

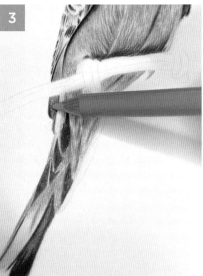

Color the backs of the wings lightly with colored pencil No. 199, and then color over that with colored pencil No. 271.

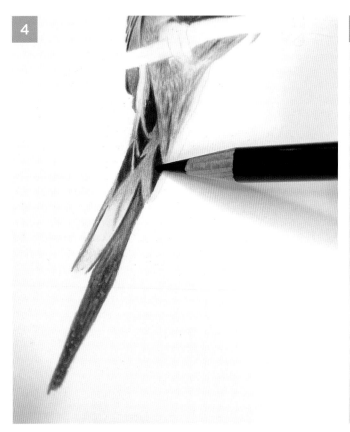

Draw the pattern of the tail feathers using colored pencil No. 199. Color over the edges of the pattern with colored pencil No. 170.

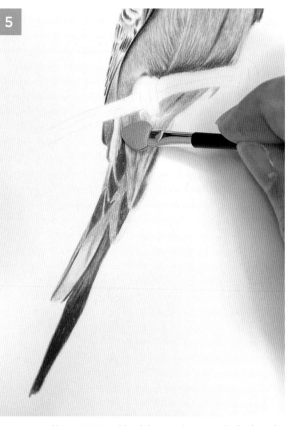

Use PanPastel® No. 26805 to blend the area between the body and the tail feathers.

5 Draw the Feet and the Branch

Depict the difference in texture between the parrot's soft feet and the hard tree branch it is grasping. Start by coloring the legs, and then color the base of the branch with PanPastel®.

THE COLORS USED AT THIS STAGE

COLORED PENCIL	176	199

PANPASTEL®	27408	27805

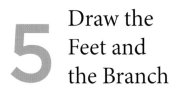

1 Color the base of the feet with Pan-Pastel® No. 27408.

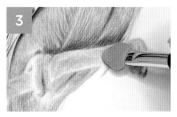

3 Color the base of the branch with PanPastel® No. 27805.

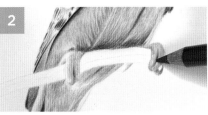

2 Using colored pencil No. 176, color the splits between the toes darkly and the shadowed areas lightly.

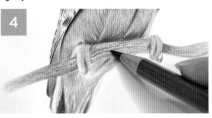

4 Color the indentations on the branch with colored pencil No. 176.

5

To create a more three-dimensional effect, draw the crevices in the tree bark with colored pencil No. 199.

The border between the foot and the branch should also be colored a little darker to give the drawing a more three-dimensional look.

6 Completion

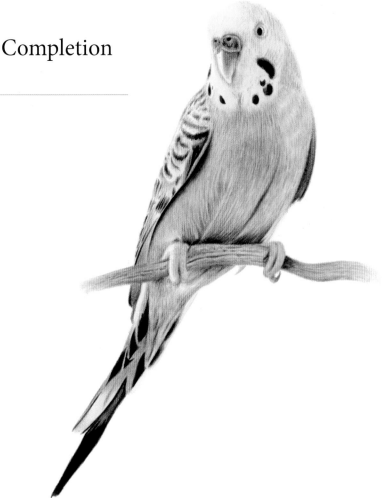

85

ESTIMATED DURATION: 13 HOURS

LEVEL: ADVANCED
Draw a Cat

Here, we will tackle a popular subject, a realistic portrait of a cat. In the subject photo, the face and head form the main parts of the picture. Carefully observe the length and flow of the fur. The fine whiskers are also important. If you have patience and take your time, you can draw a truly beautiful cat.

● **SUBJECT PHOTO**

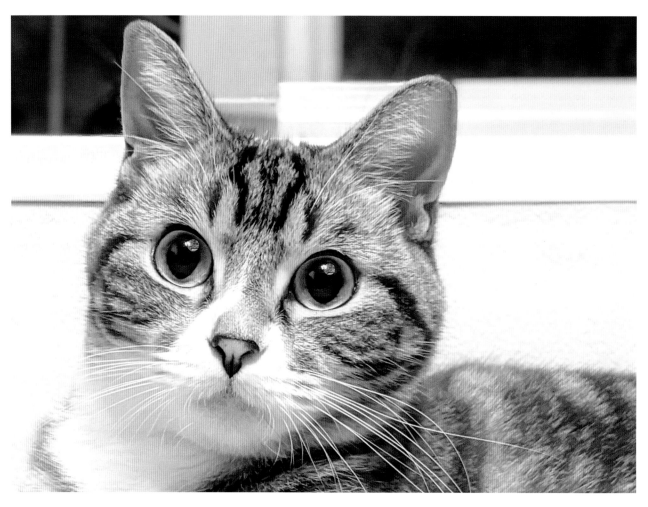

The fur on different parts of the cat has different textures and varies in length and direction.

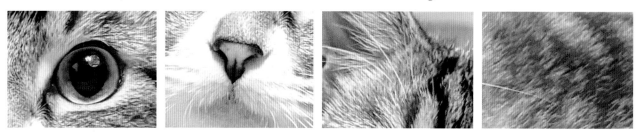

Choose colors that balance naturally with the overall color scheme.

● SEARCHING FOR COLORS

The main colors in the photograph are these:

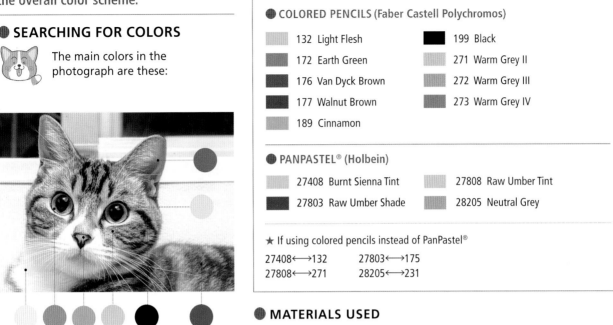

▶ These colors were selected visually. Use them as a reference for your own color search.

COLOR PALETTE (COLORS USED)

● COLORED PENCILS (Faber Castell Polychromos)

132	Light Flesh		199	Black
172	Earth Green		271	Warm Grey II
176	Van Dyck Brown		272	Warm Grey III
177	Walnut Brown		273	Warm Grey IV
189	Cinnamon			

● PANPASTEL® (Holbein)

27408	Burnt Sienna Tint		27808	Raw Umber Tint
27803	Raw Umber Shade		28205	Neutral Grey

★ If using colored pencils instead of PanPastel®

27408⟷132	27803⟷175
27808⟷271	28205⟷231

● MATERIALS USED

- Colored pencils (Faber Castell Polychromos)
- PanPastel® artists' pastels (Holbein) • Kent or Bristol drawing paper
- Tools for line drawing (mechanical pencil, kneaded eraser)
- Eraser in a holder • Steel stylus

● STEPS TO COMPLETION

1. Eyes and nose (page 88) ▶ 2. Whiskers (page 89) ▶ 3. Forehead (page 90) ▶ 4. Ears (page 90) ▶ 5. Cheeks and temples (page 91) ▶ 6. Mouth and chin (page 92) ▶ 7. Body (page 94) ▶ 8. Completion (page 95)

● LINE DRAWING

Make an enlarged copy of the line drawing on the right, and then trace it to use as a reference for your own drawing.

1 Draw the Eyes and Nose

The first step in drawing a cat is to start by drawing the glint of the eyes and the rough, matte texture of the nose. By adding strong shadows to each part, the three-dimensionality and realistic texture of the cat's face will stand out.

THE COLORS USED AT THIS STAGE

| COLORED PENCIL | 132 | 172 | 176 | 199 | 273 |
| PANPASTEL® | 27408 | | | | |

To make the eyes sparkle, it is important to depict highlights in the pupils and to draw the details of the irises.

1 Trace the outline of the line drawing with colored pencil No. 199.

2 Use PanPastel® No. 27408 to apply a light layer of color on the iris in each eye.

3 Color the edges of each iris with colored pencil No. 172, and then blend with colored pencil No. 132.

4 Color the pupils with colored pencil No. 199. Be careful not to color the areas of highlight in each pupil.

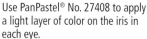
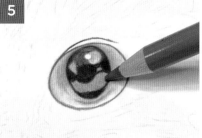
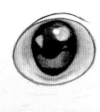

5 Tint the highlights of the eyes with colored pencil No. 273.

6 Fill in the areas, being mindful of the gradations. Use colored pencil No. 199 for the darker areas.

7 Color the upper eyelid of each eye by layering colored pencil Nos. 199 and 132.

The colors of the shadows around the nose can also be applied in layers to blend the colors and make the shadows look more natural.

SUBJECT PHOTO DETAIL ▶

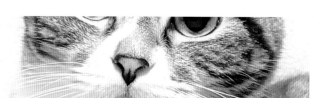

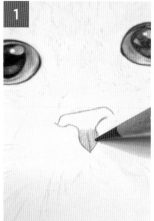
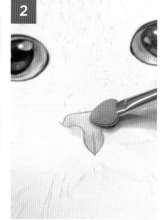
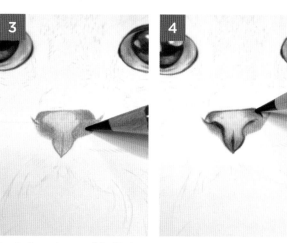

1 Draw the outline of the nose with colored pencil No. 176, and the lower part of the nose with colored pencil No. 132.

2 Use PanPastel® No. 27408 for the base layer of the nose.

3 Apply the undercoat of the black parts and the shadows with colored pencil No. 176.

4 Firmly draw the black part of the nose and the outline of the nose with colored pencil No. 199.

2 Draw the Whiskers

To draw facial fur and whiskers, start by using a steel stylus. This technique is suitable when it is difficult to use erasers or other tools, because the areas scored with the stylus will not be covered with color.

Drawing with a steel stylus is a method whereby you score a groove for thin lines, such as whiskers, to prevent color from being applied there.

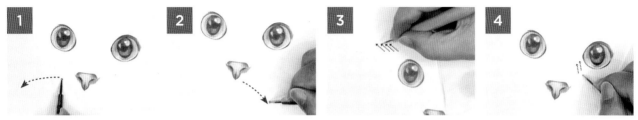

Observing the subject photo, score grooves in the paper with a steel stylus to depict the whiskers. Inscribe a steady line from the base of the whiskers to the tips.

3 Draw the Forehead Pattern

This cat has the distinctive M-shaped pattern found on the forehead of domestic tabby cats, rather than thin stripes or dots.

THE COLORS USED AT THIS STAGE

COLORED PENCIL	132	176	199	272	273
PANPASTEL®	27408	27808	28205		

1 Color the area around the eyes with colored pencil No. 199, and then add a layer of colored pencil Nos. 132 and 176.

2 Apply PanPastel® No. 27408 from the eyebrows to the nose.

3 Color the nose with colored pencil Nos. 176, 272 and 199, overlapping the colors.

4

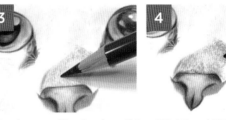

5 Apply PanPastel® No. 27808 to the bridge of the nose.

6 Draw the black pattern on the forehead with colored pencil No. 199.

7 Draw the fur pattern from between the eyebrows to the forehead in more detail using colored pencil Nos. 272, 273 and 176.

8

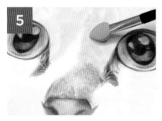

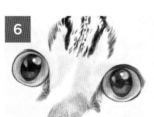

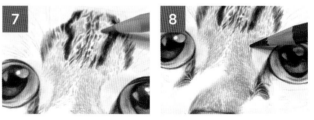

9 Color a graduated pattern with colored pencil No. 132.

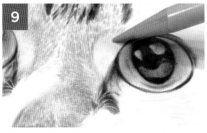

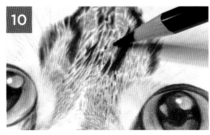

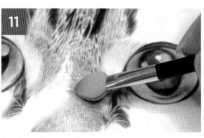

10 Finely adjust the color between the hairs with colored pencil No. 199.

11 Apply PanPastel® No. 28205 from between the eyebrows to the nasal bridge, and then blend the color.

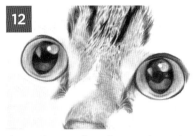

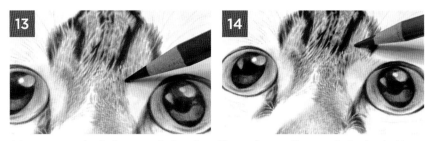

The area between the eyebrows and around the forehead has short hairs. Draw short strokes without filling in between.

If there are areas that look unnatural when viewed from a distance, fine-tune the forehead with colored pencil Nos. 176 and 273.

4 Draw the Ears

The inside of the ear may look simple, but there are many complex elements involved. In addition to applying layers of color, try the technique of using an eraser to emphasize the flow of the fur and the edge of the ear.

THE COLORS USED AT THIS STAGE

COLORED PENCIL ■ 176　■ 177　■ 178　■ 189　■ 271

PANPASTEL® ■ 27803

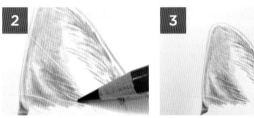

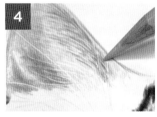

Draw the outlines and hairs with colored pencil No. 176.

Color the darker parts of the ears with colored pencil No. 176. The parts engraved with the steel stylus will not be covered with color.

Overlay the areas colored in steps 1–3 with colored pencil No. 271.

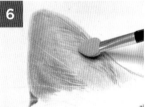

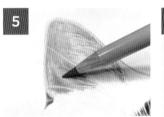

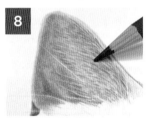

Color the flesh-colored part of the ear with colored pencil No. 189.

Apply PanPastel® No. 27803 over this and blend.

Use colored pencil No. 178 to draw a sparse pattern of fur.

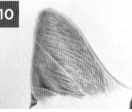

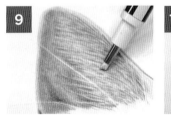

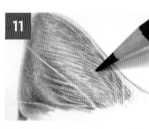

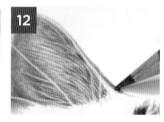

Use an eraser in a holder to erase thin lines to represent white hairs.

Fill in the dark-colored areas with colored pencil No. 17.

Draw the fine hairs from the inside to the outside with colored pencil No. 178.

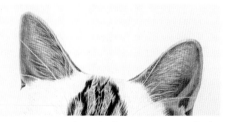

The opposite ear is drawn in the same way. Once both ears are more or less complete, compare them at a slight distance to check the balance.

Technique for depicting white hairs and whiskers

Thick hairs and whiskers are difficult to define with an eraser after coloring with colored pencils, so engrave them in advance using a steel stylus.

Use different thicknesses of stylus depending on the thickness of the hairs or whiskers.

Looking closely at the subject photo, make grooves with a steel stylus along the thicker hairs and whiskers following the line drawing.

5 Draw the Cheeks and Temples

The face is finished as a continuation of the ears. To avoid aesthetic inconsistencies between the facial features drawn in stages, continually evaluate the whole drawing as you work. The flow of the fur and the lightness and darkness of the colors will create a three-dimensional effect.

THE COLORS USED AT THIS STAGE

| COLORED PENCIL | 177 | 178 | 199 | 235 | 273 |

| PANPASTEL® | 27808 |

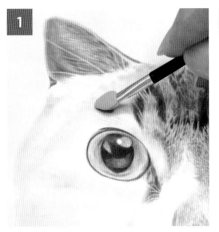

Apply a base coat of PanPastel® No. 27808 to the area above the eyes.

Draw the hairs with colored pencil Nos. 177, 273 and 199, paying attention to the direction in which the hairs flow.

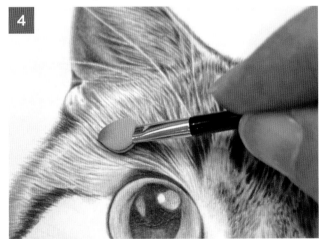
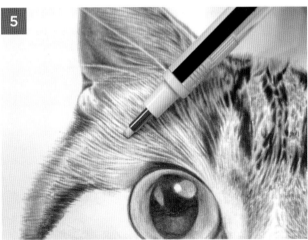

Apply PanPastel® No. 27808 over the top and blend.

Erase thin lines with the eraser in a holder, as if you were drawing white hairs.

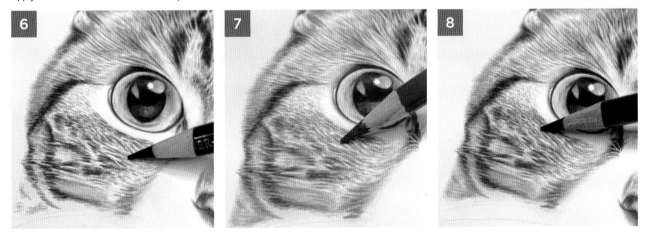

The hairs on the cheeks are also drawn with colored pencil Nos. 177, 178, 199 and 235, paying attention to the detailed patterns and the direction in which the hairs flow.

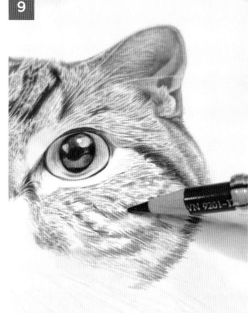

9

Color the opposite side of the face in the same way. Compare the left and right sides of the face and make fine adjustments so that the overall balance does not look unnatural.

10

11

Color the hairs one by one, while being conscious of the flow of the hairs. By layering the colors over and over again, realistic fur can be reproduced.

6 Draw the Mouth and Chin

A cat's whiskers occupy a large part of the area from its mouth down. In order to express the whiskers realistically, carefully draw every detail, making full use of the grooves engraved by the steel stylus as well as the eraser in a holder. At the same time, make sure the bottom of the face blends with the upper part.

THE COLORS USED AT THIS STAGE

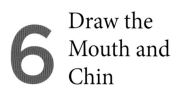

| COLORED PENCIL | | 177 | | 178 | | 271 | | 273 |
| PANPASTEL® | | 27408 | | | | | | |

Steel styluses and erasers are useful for depicting whiskers and fur.

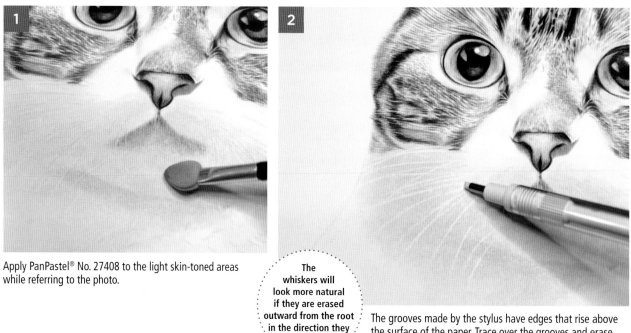

1

Apply PanPastel® No. 27408 to the light skin-toned areas while referring to the photo.

The whiskers will look more natural if they are erased outward from the root in the direction they are growing.

2

The grooves made by the stylus have edges that rise above the surface of the paper. Trace over the grooves and erase the whiskers with an eraser in a holder.

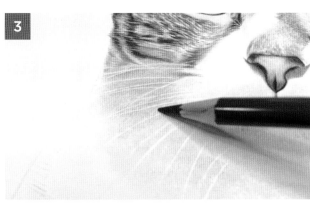

Color the shadows in between the whiskers with colored pencil No. 178.

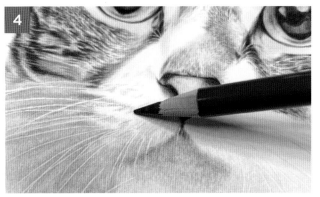

Use colored pencil Nos. 178 and 273 to color the base of the whiskers a little darker under the grooves of the stylus.

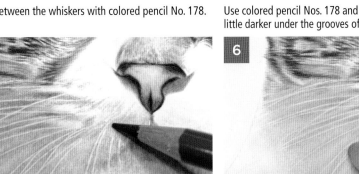

Draw with colored pencil No. 27, being careful not to apply too much pressure.

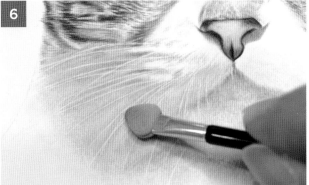

Apply PanPastel® No. 27408 on top and blend.

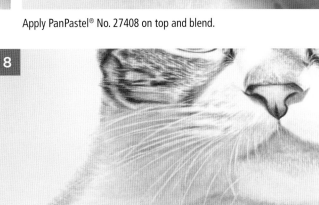

The dark flow of fur is drawn with colored pencil Nos. 178 and 273, and the light flow of fur is drawn gently with colored pencil No. 271.

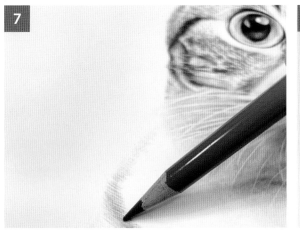

Layer on PanPastel® No. 27408 under the chin in an upward direction and blend.

Repeat for the other side of the face, looking carefully at the previously drawn side and balancing the drawing so that it looks natural. For the darker areas, use colored pencil No. 177 in layers.

7 Draw the Body

The final step is to finish the cat's body. The fur line on the body is clearly shaded into darker and lighter areas. The hairs should be depicted individually in the direction of the flow, and then blended with PanPastel®.

THE COLORS USED AT THIS STAGE

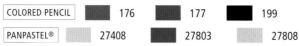

| COLORED PENCIL | 176 | 177 | 199 |
| PANPASTEL® | 27408 | 27803 | 27808 |

The key to effectively connecting the face and body is to draw the details well and balance the color tones.

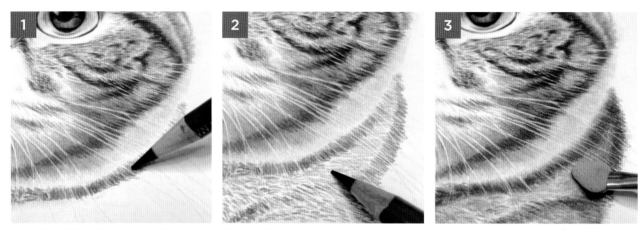

Draw the dark fur with colored pencil No. 177, and draw the slightly lighter fur with colored pencil No. 176. If the fur does not look thick enough, use colored pencil No. 199 to draw over it.

Apply PanPastel® No. 27803 over the previous layer and blend the colors.

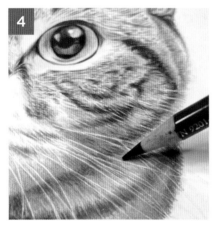 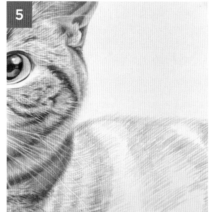 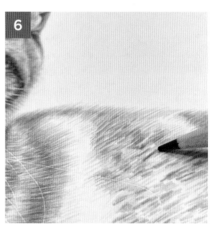

Draw between the whiskers grooved with the steel stylus using colored pencil No. 177.

Draw the flow of fur with colored pencil No. 176.

Layer the darker areas with colored pencil No. 177.

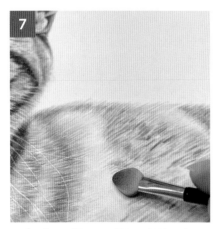 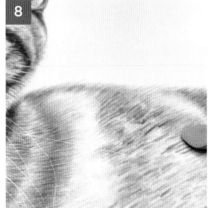 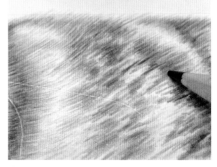

Apply a layer of PanPastel® No. 27808 and blend the colors.

Apply a layer of PanPastel® No. 27408 on the lighter areas.

If the PanPastel® becomes too light, supplement with colored pencil No. 177.

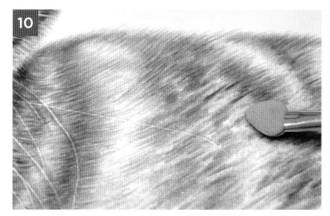

Form a smooth gradation over the entire body using PanPastel®
No. 27408.

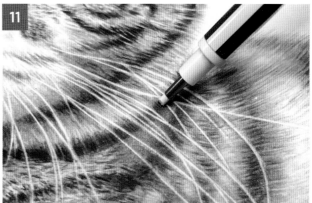

Using an eraser in a holder, erase the long whiskers overhanging the body,
tracing the marks made by the stylus. Cut the eraser at an angle with a
utility knife to make it thinner. Freely erase along the hairline.

8 Completion

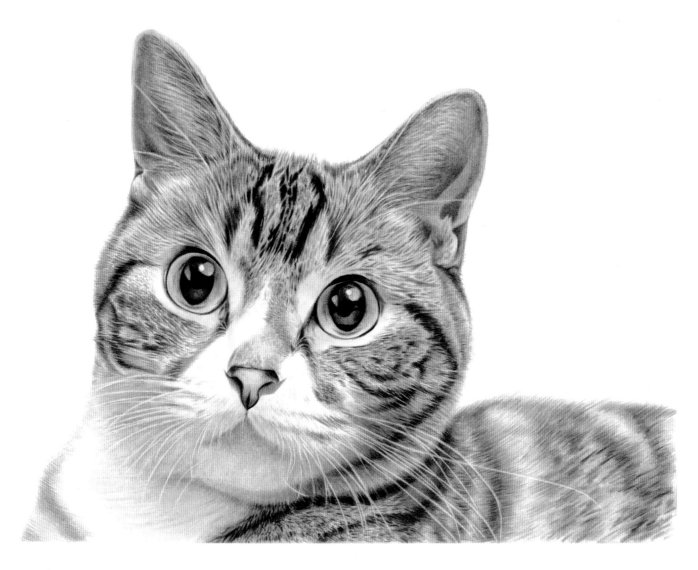

ESTIMATED DURATION: 3 HOURS

LEVEL: ADVANCED

Draw a Corgi

A corgi is characterized by its rounded ears, its cute mouth that looks like it is smiling and its rather short body height. It has five "fingers" on its front paws and four "toes" on its back paws. Did you know that the Cocomaru cartoon character is also a corgi? Let us draw the corgi realistically to express its cuteness.

● **SUBJECT PHOTO**

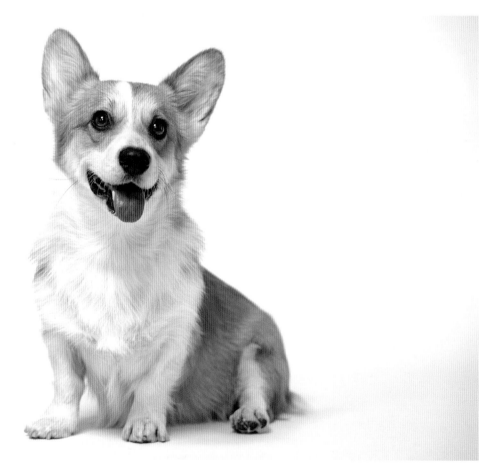

Capture the flow of the fluffy fur around its chest.

• •

The fur on a corgi's chest flows primarily to the left and right. The fur does not flow in a straight line in one direction, but rather in waves. Enlarge the subject photo to observe how the fur flows.

The colors may look simple, but there is intricacy in the details.

● SEARCHING FOR COLORS

 The main colors in the photograph are identified at right.

▶ These colors were selected visually. Use them as a reference for your own color search.

● MATERIALS USED

- Colored pencils (Faber Castell Polychromos)
- PanPastel® artists' pastels (Holbein)
- Kent or Bristol drawing paper • Eraser in a holder
- Steel stylus • Tools for line drawing (mechanical pencil, kneaded eraser) • Tissue paper

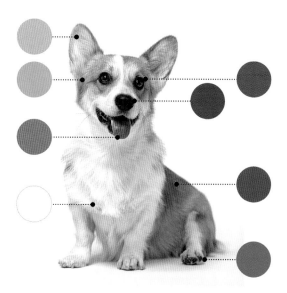

COLOR PALETTE (COLORS USED)

● COLORED PENCILS (Faber Castell Polychromos)

	124	Rose Carmine
	131	Medium Flesh
	176	Van Dyck Brown
	177	Walnut Brown
	179	Bistre
	180	Raw Umber
	181	Payne's Grey
	182	Brown Ochre
	186	Terracotta
	187	Burnt Umber
	189	Cinnamon
	190	Venetian Red
	199	Black
	233	Cold Grey IV
	234	Cold Grey V
	249	Mauve
	263	Caput Mortuum Violet
	272	Warm Grey III
	273	Warm Grey IV

● PANPASTEL® (Holbein)

	27803	Raw Umber Shade
	24305	Magenta
	27405	Burnt Sienna
	27408	Burnt Sienna Tint
	28005	Black
	28205	Neutral Grey

★ If using colored pencils instead of PanPastel®

27803←→175 24305←→125 27405←→186
27408←→132 28005←→132 28205←→231

● STEPS TO COMPLETION

1. Eyes and nose (page 98) ▶ 2. Mouth (page 99) ▶ 3. Ears to face (page 100) ▶ 4. Upper body (page 104) ▶ 5. Front and back feet (page 106) ▶ 6. Lower body (page 108) ▶ 7. Completion (page 109)

● LINE DRAWING

Make an enlarged copy of the line drawing below, and then trace it to use as a reference for your own drawing.

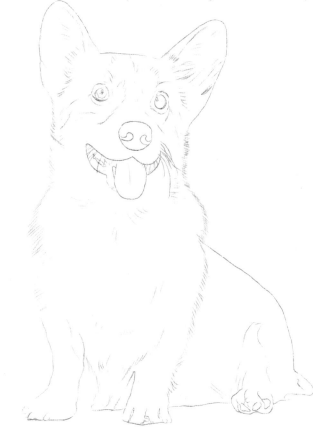

1 Draw the Eyes and Nose

A corgi's eyes are round and three-dimensional. Its distinctive nose is drawn in a way that gives it a unique quality in combination with highlights.

THE COLORS USED AT THIS STAGE

| COLORED PENCIL | 181 | 186 | 199 |
| PANPASTEL® | 28005 |

Color pencils are used to create a surface rather than lines. When coloring over a surface, use light or strong pressure to get the desired color.

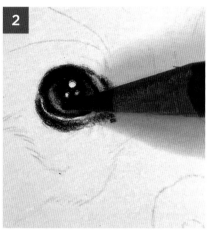

Using colored pencil No. 199, draw the black parts of the eye on the left and the area around the eye, and then use colored pencil No. 181 to make the edges of the eye darker to give it a gradated look.

Draw the pupil with colored pencil No. 186 and blend it with colored pencil No. 181.

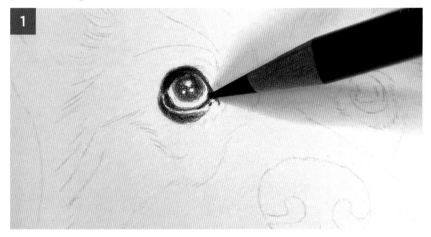

Draw the other eye in the same way, checking the balance.

Color around the highlights of the nose so that the white of the paper shows through.

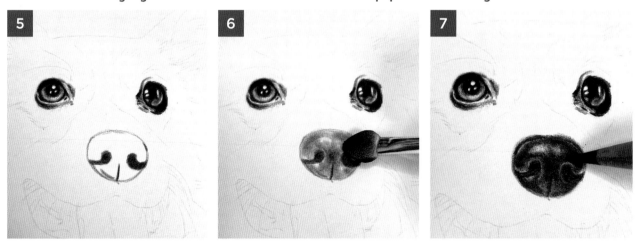

Color the nose in the same way with colored pencil No. 199, and then color the middle part of the nose with PanPastel® No. 28005. Color around the highlighted part of the nose so as to leave the white base paper color exposed.

Darken the nose with colored pencil No. 199, taking care with the density of the color and using varying pressure to create a three-dimensional effect.

2 Draw the Mouth

The white whiskers over the mouth are engraved with a steel stylus. The thickness and texture of the tongue can also be expressed by depicting the areas that are brightly lit and those that are in shadow.

THE COLORS USED AT THIS STAGE

COLORED PENCIL	124	131	177	190	199
	249	263	PANPASTEL®	24305	

Gradation is an important skill in drawing the tongue in a realistic manner. In this case, we will use a short gradient to make it look natural.

1
Use a steel stylus to make grooves to produce the white hairs in front of the mouth.

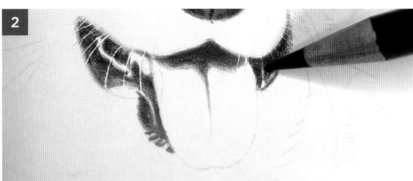

2
Observe the subject photo carefully and fill in the dark areas along the line drawing with colored pencil No. 199.

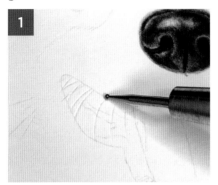

3 4 5
Color the base of the tongue with PanPastel® No. 24305. Use colored pencil No. 131 for the darker areas, and erase the highlights on the tongue with the eraser in a holder. To create more shading, fine-tune the color with colored pencil No. 190.

Use colored pencil No. 249 to create a gradient at the back of the tongue.

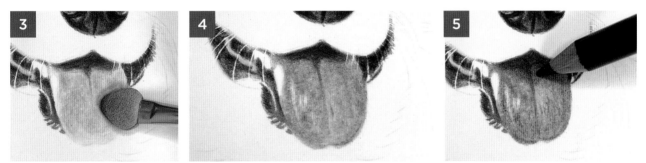

6 7 8

The darkest part of the mouth is colored in warm colors using colored pencil Nos. 199 and 177.

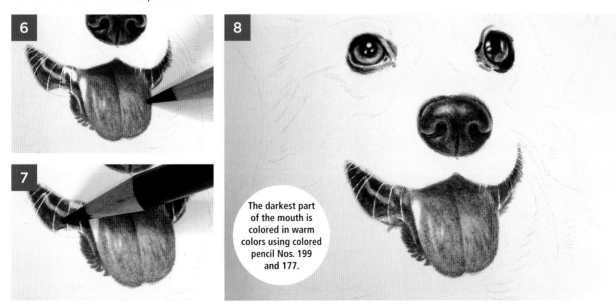

Use colored pencil No. 263 to color over and fine-tune the areas that are slightly reddish to black in the photo, such as the back of the tongue and darker areas on the front part of the tongue.

3 Draw from the Ears to the Face

Observe the flow of the hairline in the subject photo and draw around the eyes and into the ears. The base of the face is colored with PanPastel®, and the fur is added on top of the base.

THE COLORS USED AT THIS STAGE

COLORED PENCIL	176	177	179	180	181
	182	187	189	190	199
	263	272	273		
PANPASTEL®	22803	27408	28205		

Once the outline of the face is drawn, carefully draw in the flow of the fur.

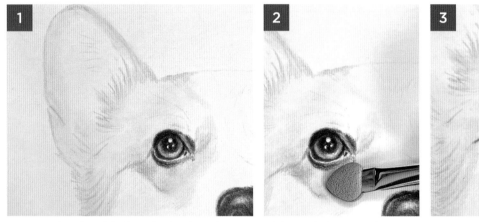

Draw a rough outline of the fur with colored pencil No. 182, and then apply the base with PanPastel® No. 22803.

Emphasize the darker areas with colored pencil No. 179.

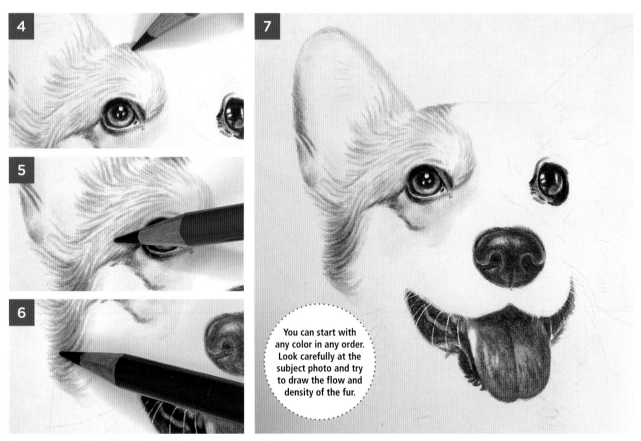

You can start with any color in any order. Look carefully at the subject photo and try to draw the flow and density of the fur.

Use colored pencil Nos. 182, 187 and 177 to show the flow of the fur.

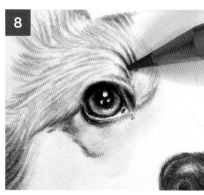

8

Indicate the brow ridge with colored pencil Nos. 199 and 273, and blend into the layer below.

9

Color around the eyes with colored pencil No. 263. The color is richer than black alone, and it blends into the color of the surrounding fur. Deepen the color using PanPastel® No. 22803.

10

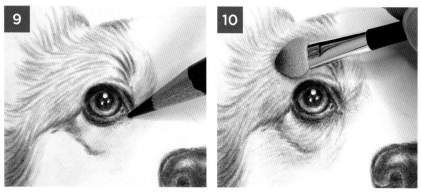

11 **12** **13**

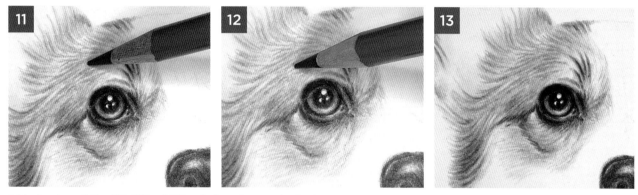

Add colored pencil Nos. 182, 187 and 177 to the fur to increase the density.

Draw from the eyes to the ears.

14 **15**

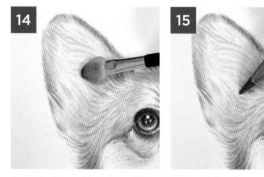

Apply the base with PanPastel® No. 27408, and then draw a thin coat of hair using colored pencil Nos. 272 and 273. Add a reddish tone using colored pencil Nos. 189 and 190.

18

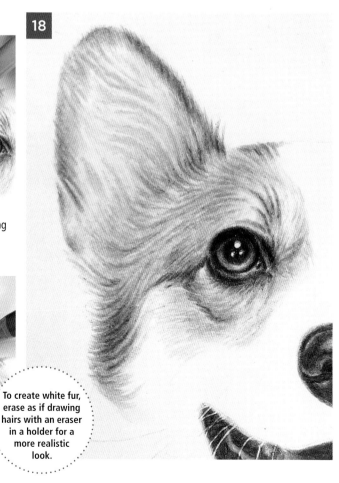

16 **17**

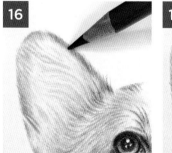

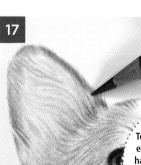

Draw the short hairs on the outside of the ear with colored pencil No. 176, and then draw over it with colored pencil No. 180.

> To create white fur, erase as if drawing hairs with an eraser in a holder for a more realistic look.

Draw the other side of the face in the same way.

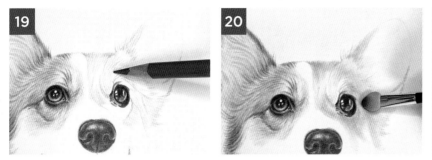

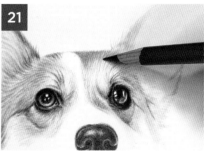

Draw the fur on the left side in the same way as the other side using colored pencil No. 182, and then apply the base using PanPastel® No. 22803.

Draw the fur with colored pencil No. 182.

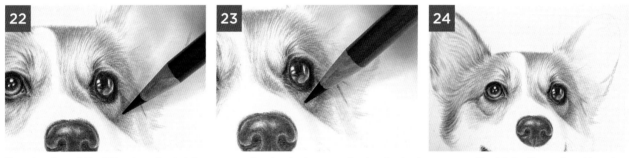

Use colored pencil No. 177 to draw the dark furrows around and under the eyes, adjusting the density as you see fit while looking at the subject photo.

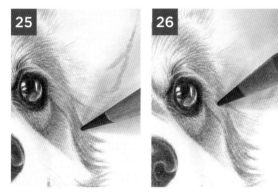

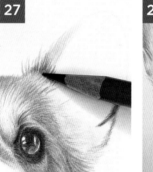

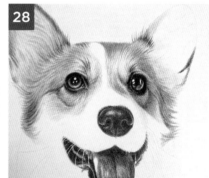

Use colored pencil Nos. 182 and 187 to add depth to the color of the fur.

Draw the dark hairs on the ears with colored pencil No. 177, and then use colored pencil Nos. 180 and 176 to draw the dark hairs at the base of the ears.

Draw the opposite ear while being aware of the balance.

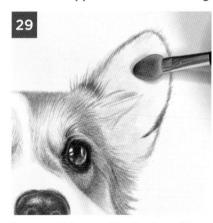

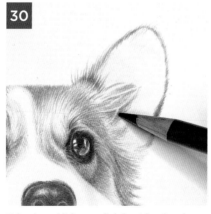

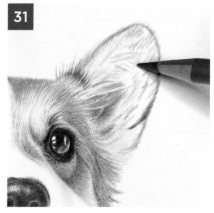

Draw around the ears with colored pencil No. 176, and then color the inside with PanPastel® No. 27408.

Color the reddish areas lightly with colored pencil No. 190, and then color over them with colored pencil No. 263, paying attention to the way the hairs grow.

Draw the light-colored hairs in the ears with colored pencil No. 273. Use light pressure to draw the hairs thinly.

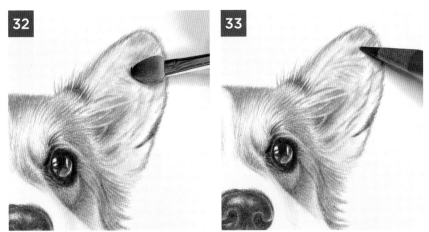

Apply a layer of color with PanPastel® No. 28205, and then add more with colored pencil No. 273.

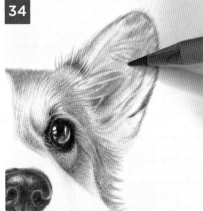

Put a thin layer of color in the center part of the ear with colored pencil No. 189.

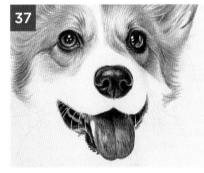

Draw more detail with colored pencil Nos. 176 and 180.

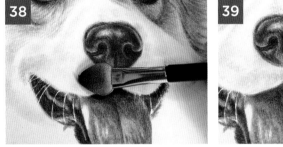

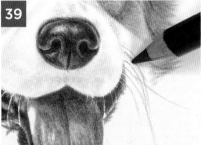

Blend in the fur with PanPastel® No. 22803.

Draw the shadow under the nose to achieve a three-dimensional effect.

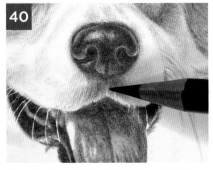

This is how it looks before the shadow is drawn.

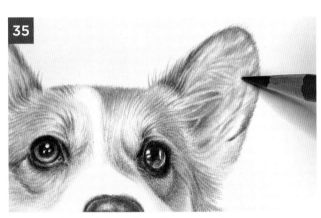

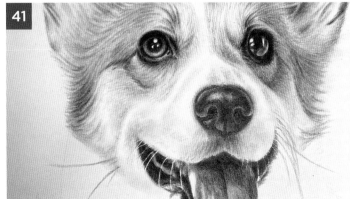

Color the shadow around the nose and mouth with PanPastel® No. 28205. Use colored pencil No. 273 to fine-tune the darker areas. Use colored pencil No. 181 to draw a thin line to define the whiskers.

Use colored pencil Nos. 199, 181 and 273 to draw the shadow under the nose.

4 Draw the Upper Body

The body should be drawn in two parts: the upper part and the lower part. The key point of the upper part is the white fluffy fur from the face down. The three-dimensionality of the fluffy fur is expressed by erasing rather than drawing.

THE COLORS USED AT THIS STAGE

COLORED PENCIL	176	177	187	234
	272	273		
PANPASTEL®	22803	27405	28205	

The face and body parts are connected using natural tones.

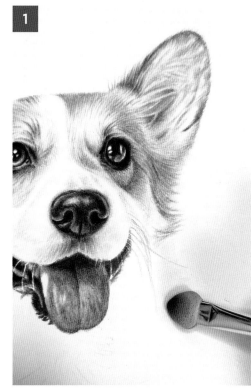
1

Apply the base with PanPastel® No. 22803.

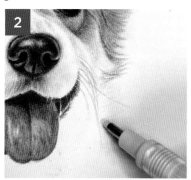
2

Erase the PanPastel® with the eraser in a holder as if you were drawing hairs.

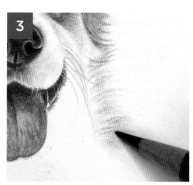
3

Draw the flow of fur over the erased parts with colored pencil Nos. 187 and 176.

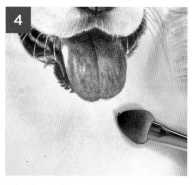
4

Color the shadow under the neck with PanPastel® No. 28205 following the flow of the fur.

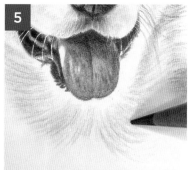
5

Highlight the fur under the neck with colored pencil No. 273.

· ·

Apply several layers of color to make the fur look full and fluffy.

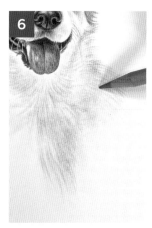
6

Use colored pencil Nos. 273 and 234 for the parts where the shadow is dark.

7

Color the brown area at the base of the leg with PanPastel® No. 27405.

8

9

Color the white fur with PanPastel® No. 28205, and then draw a thin coat of fur with colored pencil No. 273. Draw the brown part at the base of the legs with colored pencil No. 177.

Use an eraser in a holder to erase as you "draw."

KEY POINT The white flow of the fur is not drawn with white pencils, but by applying a base with gray PanPastel® and then erasing it with an eraser in a holder as if you were drawing lines. PanPastel® is an erasable drawing material, but a light color will remain on the erased lines. A line of hairs using colored pencils is then drawn on top of the erased lines. More can be added, if necessary. By repeating the process of drawing and erasing, a fluffy fur pattern emerges.

Draw the details of the fur as finely as possible.

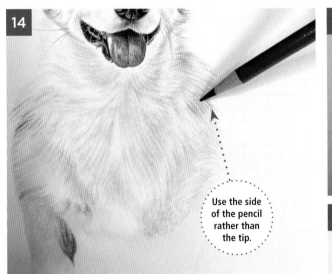

Use the side of the pencil rather than the tip.

Draw the brown areas with colored pencil No. 176, and then overlay them with colored pencil No. 273.

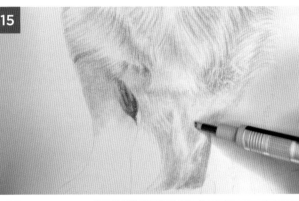

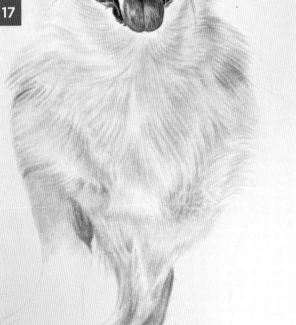

Color the fur on the belly with PanPastel® No. 28205. Draw the hairs with colored pencil No. 272. Use the eraser in a holder to erase parts of the fur, and then use colored pencil No. 176 to add a brownish tint to the darker areas in the shadows.

5 Draw the Front and Back Feet

Dogs have cushioned paw pads on their soles and claws emerging from their toes. The structure and roles of the front and hind feet are also different, so capturing these characteristics in the drawing will create a more realistic look.

THE COLORS USED AT THIS STAGE

COLORED PENCIL	176	177	180	181	182
	189	199	234	263	272
	273	PANPASTEL®	27405	28205	

Be aware of the structure of the feet and carefully draw the details and shadows.

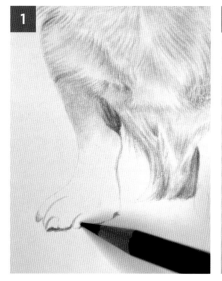

Color the "fingers" and forelegs with colored pencil No. 180, and the ground with colored pencil No. 181.

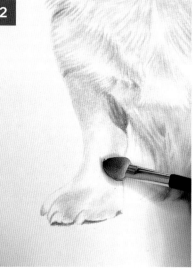

Color the shadow areas with PanPastel® No. 28205.

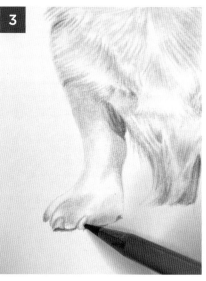

Draw the claws and the forelegs with colored pencil No. 189.

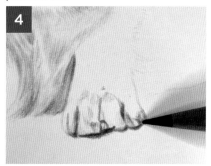

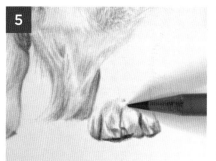

Use colored pencil No. 181 for the contours of the opposite paw, colored pencil No. 189 for the pinkish part of the claws, and colored pencil Nos. 177, 263 and 182 for the details. Add a gray tint with colored pencil No. 273.

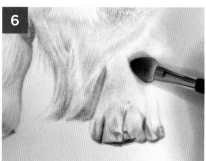

Apply a thin coat of PanPastel® No. 28205 to the shadowed areas of the white fur, and then add the fur detail with colored pencil No. 272.

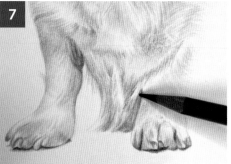

To add brownish color to the fur from the paws to the belly, blend with colored pencil No. 176.

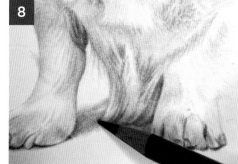

For the shadow of the paws, apply PanPastel® No. 28205, and then draw the darker shades with colored pencil No. 273.

KEY POINT
Use colored pencil No. 234 to fine-tune any areas that lack density.

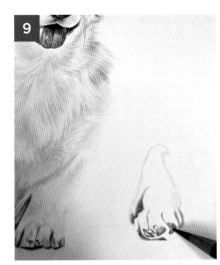

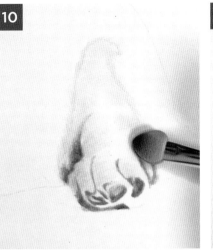

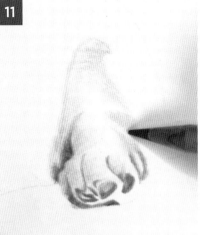

Draw the outline of the hind feet with colored pencil No. 182, and then draw the space between the "toes" and the fleshy part of the paws with colored pencil No. 177.

Color the base with PanPastel® No. 27405, and then use colored pencil No. 189 with varying pressure to give the feet the appearance of foreshortening.

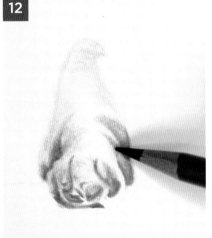

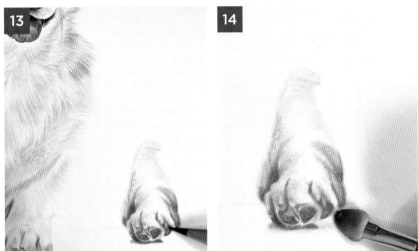

Color with colored pencil No. 177, paying attention to shading. Continue with PanPastel® No. 28205.

Use colored pencil No. 199 to draw the darker areas, such as the ground surface and the shadows between the "toes," and then use PanPastel® No. 28205 on top. Fine-tune the shading with colored pencil No. 234.

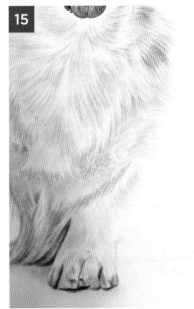

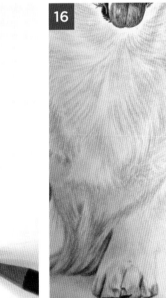

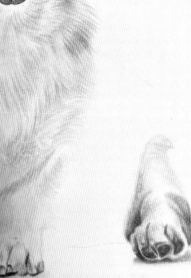

6 Draw the Lower Body

Draw and finish the torso section connecting the front and back legs. To ensure that the overall tone looks uniform, always pull back to inspect the whole image to make sure that the overall balance of light, dark and shade of the colors is correct.

THE COLORS USED AT THIS STAGE

COLORED PENCIL	176	177	180	233
	263	273		
PANPASTEL®	22803	27405	28205	

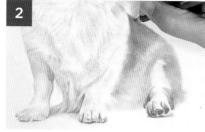

1 Use PanPastel® No. 22803 as the base, and apply a layer of PanPastel® No. 27405 on top of the darker areas.

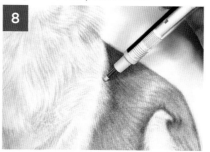

2 Using colored pencil Nos. 180, 176 and 263, draw the flow of hair from the back to the belly.

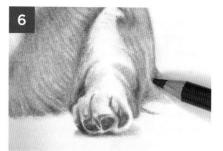

3 Color the dark shadowed parts of the leg with colored pencil No. 177.

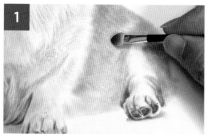

4 Layer on PanPastel® No. 27405.

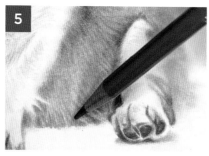

5 Color the shadowed parts of the belly hair darkly with colored pencil No. 273.

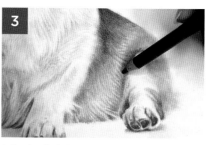

6 Draw the flow of fur from the hips to the hind legs using colored pencil No. 180.

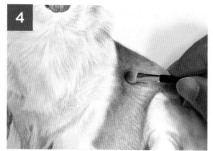

7 Color the darker areas, such as the outline of the body and the border with the feet, with colored pencil No. 177.

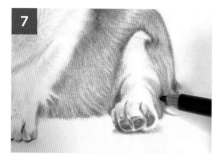

8 Soften the boundary between the white and brown fur with the eraser in a holder.

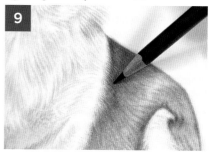

9 Finely adjust any areas that were overly erased or lack color with colored pencil No. 177.

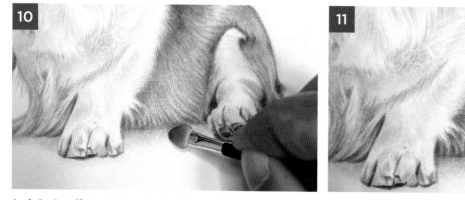

10 / 11 Apply PanPastel® No. 28205 to the shaded area where the corgi is in contact with the floor, and add density with colored pencil Nos. 177 and 233.

7 Completion

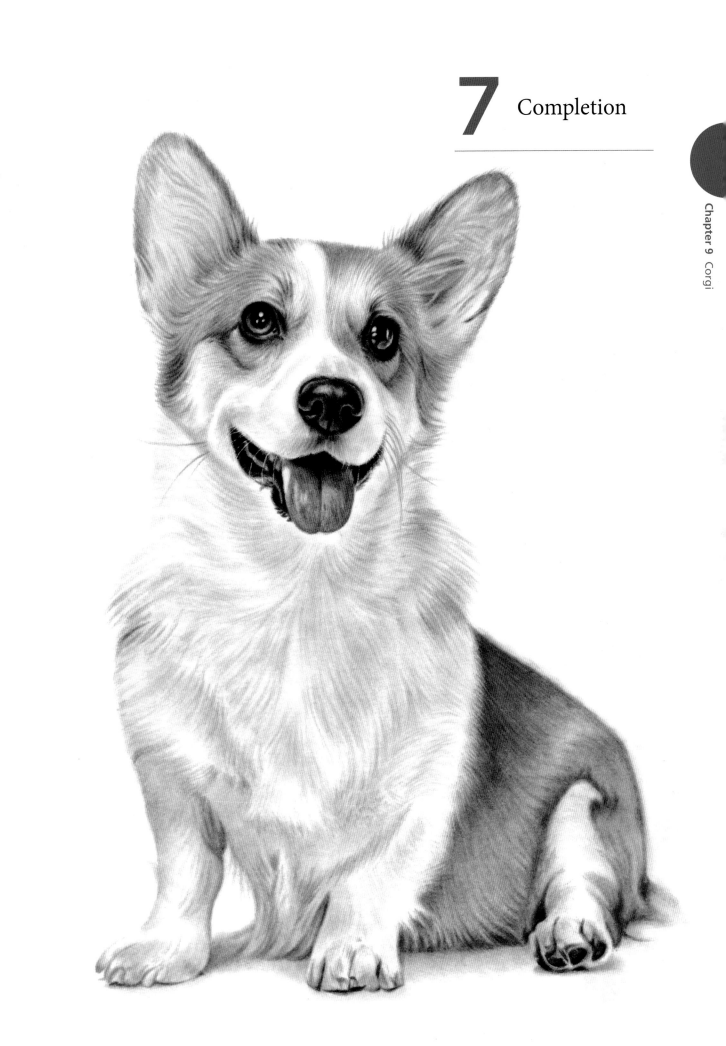

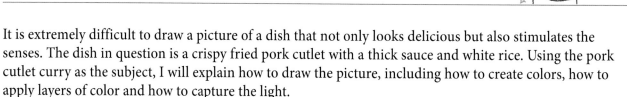

ESTIMATED DURATION: 15 HOURS

LEVEL: ADVANCED
Draw a Katsu Curry Dish

It is extremely difficult to draw a picture of a dish that not only looks delicious but also stimulates the senses. The dish in question is a crispy fried pork cutlet with a thick sauce and white rice. Using the pork cutlet curry as the subject, I will explain how to draw the picture, including how to create colors, how to apply layers of color and how to capture the light.

● SUBJECT PHOTO

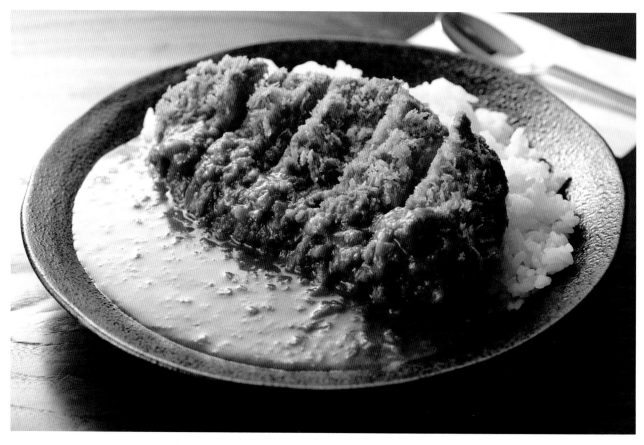

This chapter explains how to depict a dish so realistically that you can practically smell the spicy curry aroma wafting in the air and hear the delicious crispiness of the fried pork cutlet.

● ●

The most important thing here is how to depict light: the reflection of the light from the sauce, the reflection of the pork cutlet and the light and shadow of the rice. The interplay of light and shadow can be clearly seen in black and white.

The delicious aspects of the dish are depicted by dividing the subject into four parts.

The secret to the crunchy texture of the breading.

1. Draw the pork cutlet

The light is directed from the back of the pork cutlet, highlighting the edges of the breaded coating and the upper part of the breading. Understanding the direction of the light is an important factor in depicting how delicious a dish is.

Feel the creamy texture of the curry sauce.

2. Draw the curry sauce

This curry sauce is lit from the back and is strongly reflective, so it is actually lighter in color than the eye perceives. The key is not to overcolor the image.

Each grain of rice is drawn with care.

3. Draw the rice

The impression of fluffy rice comes from the way that each grain is translucent and shiny. Make sure that the colors are not muddy.

Draw the hard texture of the ceramic plate.

4. Draw the plate and the shadow

When looking at the plate as a whole, it is divided into highlights and dark areas, each with a different look. Here, I will explain how to draw the textures of the plate.

COLOR PALETTE (COLORS USED)

● COLORED PENCILS (Faber Castell Polychromos)

102	Cream	192	Indian Red
108	Dark Cadmium Yellow	199	Black
109	Dark Chrome Yellow	232	Cold Grey III
117	Light Cadmium Red	270	Warm Grey I
177	Walnut Brown	272	Warm Grey III
188	Sanguine	283	Burnt Sienna

● PANPASTEL® (Holbein)

22705	Yellow Ochre	27405	Burnt Sienna
22708	Yellow Ochre Tint	28005	Black
23803	Red Iron Oxide Shade		

★ If using colored pencils instead of PanPastel®

22705⟷183 23803⟷192 27405⟷186

● MATERIALS USED

- Colored pencils (Faber Castell Polychromos)
- PanPastel® artists' pastels (Holbein)
- Kent or Bristol drawing paper
- Tools for line drawing (mechanical pencil, kneaded eraser)
- Eraser in a holder

● STEPS TO COMPLETION

1. Fried pork cutlet (page 112) ▶ 2. Curry sauce (page 118) ▶ 3. Rice (page 121) ▶ 4. Plate and shadows (page 122) ▶ 5. Completion (page 124)

● LINE DRAWING

Make an enlarged copy of the line drawing below, and then trace it to use as a reference for your own drawing.

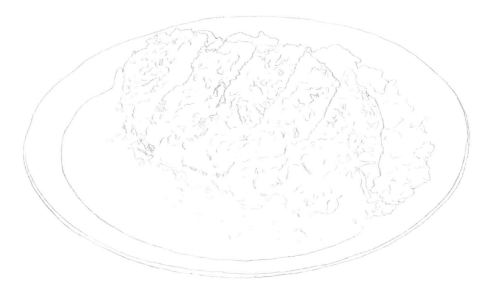

1 Draw the Fried Pork Cutlet

The highlights that accentuate the edges of the pork cutlet with the crispy breaded crust are important elements of the dish. Find the colors that bring out the realism of the dish and color them in carefully.

THE COLORS USED AT THIS STAGE

COLORED PENCIL	108	109	117	177
	188	192	199	283
PANPASTEL®	22705	23803	27405	

As you can see in the "Color Search" below, a fried pork cutlet is made up of many different colors. Which color is best? What colors can we mix with other colors to achieve the ideal color? Let us start by doing some experimentation.

● SEARCHING FOR COLORS

The main colors in the photograph are these:

▶ These colors were selected visually. Use them as a reference for your own color search.

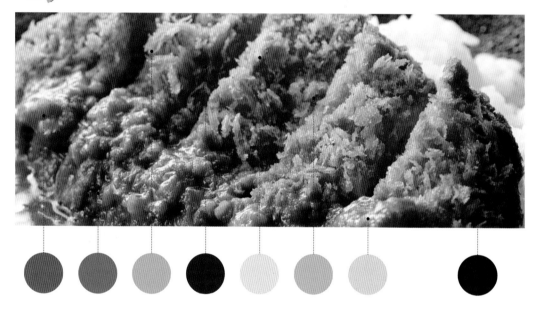

Once the main and supporting colors have been checked, you are ready to go. First, accurately trace the outlines of the pork cutlet and curry sauce in the preliminary line drawing.

Trace the outline of the fried pork cutlet and the curry sauce using colored pencil No. 199.

The five pieces of the fried pork cutlet may initially look the same, but the colors are slightly different depending on how the light is reflected on them.

Piece 1 is composed entirely of bright colors with light coming from the back, while piece 5 has a slightly heavier look with shadows cast in the foreground. Be aware of the characteristics of each piece and its three-dimensionality, and take care when drawing.

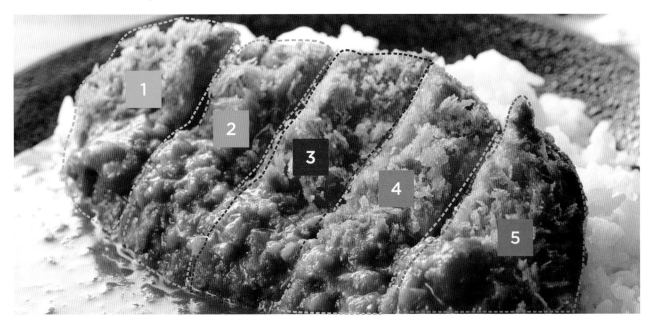

● Piece 1

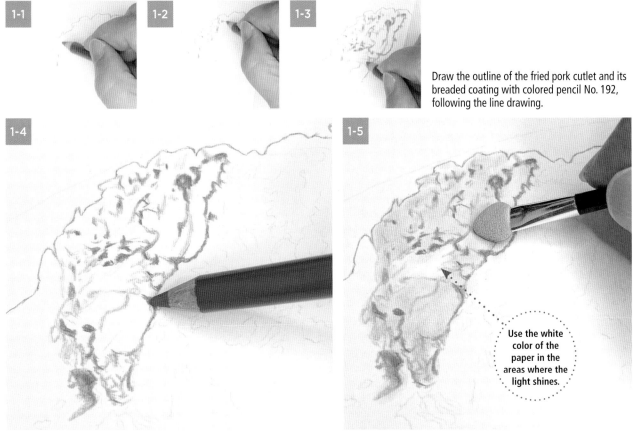

Draw the outline of the fried pork cutlet and its breaded coating with colored pencil No. 192, following the line drawing.

Use the white color of the paper in the areas where the light shines.

Draw over the shadowed areas in advance to make them darker. You should always be aware of where you are applying color on the first piece as you can make adjustments later.

Use PanPastel® No. 22705 to apply a base coat to the entire piece. Do not color too thickly at the beginning, but add colors thinly so that you can adjust them later.

To create a three-dimensional effect over a base of PanPastel®, apply layers of colors, making fine adjustments as you go along. Carefully color over each slice, one by one.

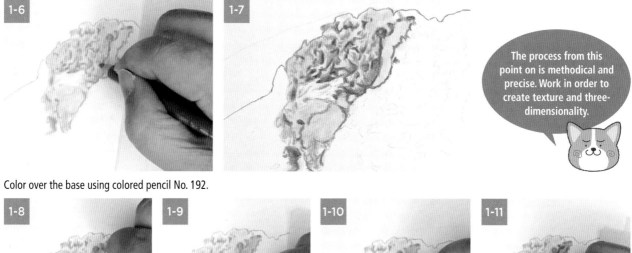

> The process from this point on is methodical and precise. Work in order to create texture and three-dimensionality.

Color over the base using colored pencil No. 192.

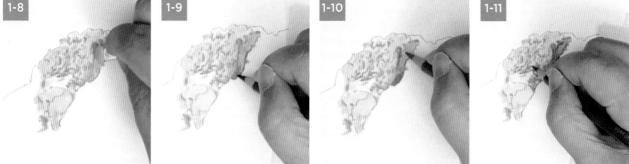

The slightly darker areas are colored with PanPastel® No. 27405 and layered with colored pencil Nos. 188, 192 and 283 a little at a time.

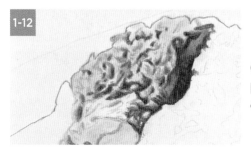

Color in the top of piece 1 using light and dark shading.

> The strong edges of the breaded crust are easier to draw if you sharpen the lead of the colored pencils.

The highlights of the curry sauce should remain the color of the paper, while the carrots should be colored with strong layers of orange.

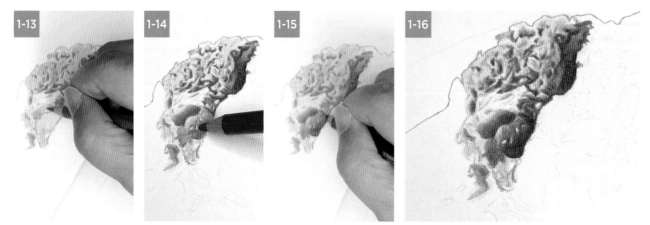

Use colored pencil No. 192 to fill in the areas covered with curry sauce, and colored pencil No. 117 to fill in the carrot details.

● Here are the coloring processes for pieces 2, 3 and 4.

● Piece 2

● Piece 3

● Piece 4

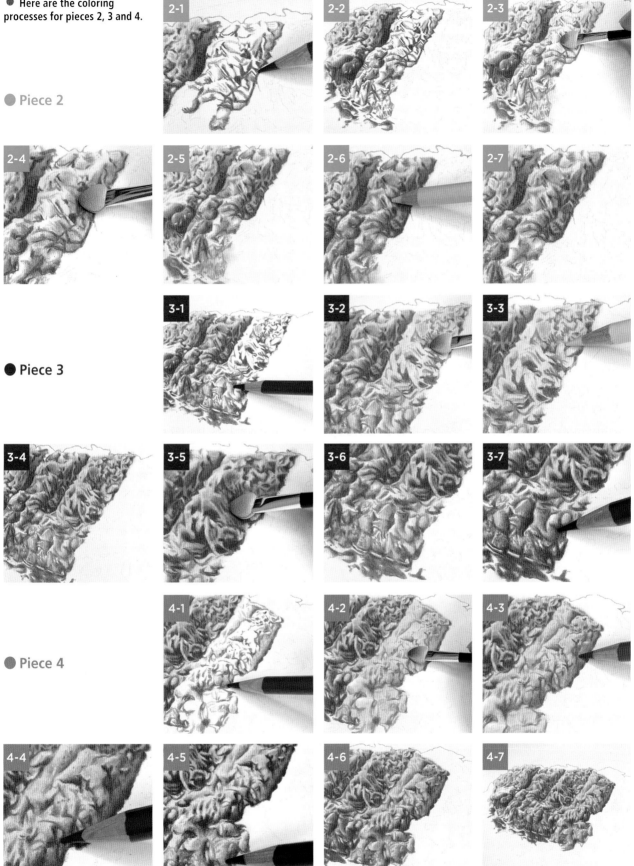

The basic drawing method is the same as for piece 1 starting on page 113, but to make the shadows darker toward the front, use colored pencil Nos. 177 and 192. Use No. 199 to add more density. Use colored pencil No. 109 on the lighter areas.

● Piece 5

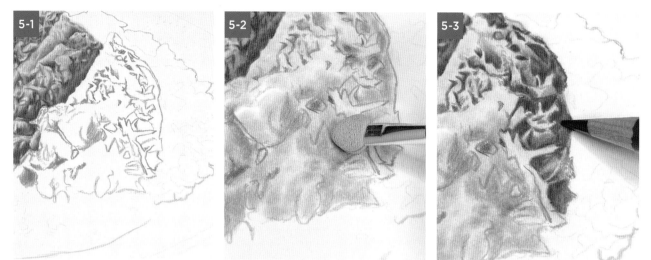

Start by coloring the darker areas and edges of the breading, and then add more density. Color the base with PanPastel® Nos. 22705 and 23803, and then color over the thinned outlines with colored pencil No. 177.

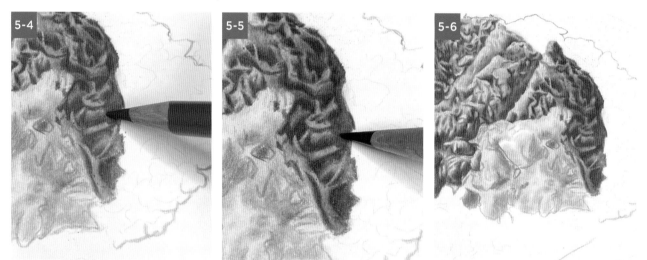

Using the same colored pencils and PanPastel® as above, draw in the details of the breading. Start with lighter colors and gradually build up to darker ones.

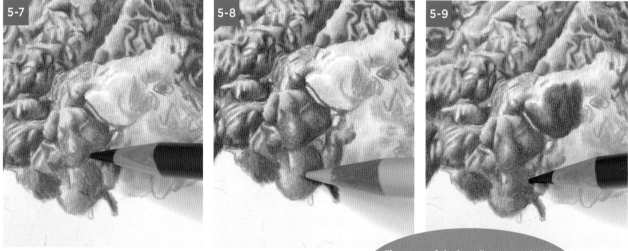

What remains is to finish the parts that are covered with curry sauce. Use colored pencil Nos. 283, 108, 177 and 188. The carrot should have a strong orange color; so use colored pencil Nos. 117 and 192.

The areas of the breading covered with sauce have a soft texture, so rounding the pencil tip slightly makes drawing them smooth and easy.

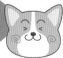

5-10

5-11

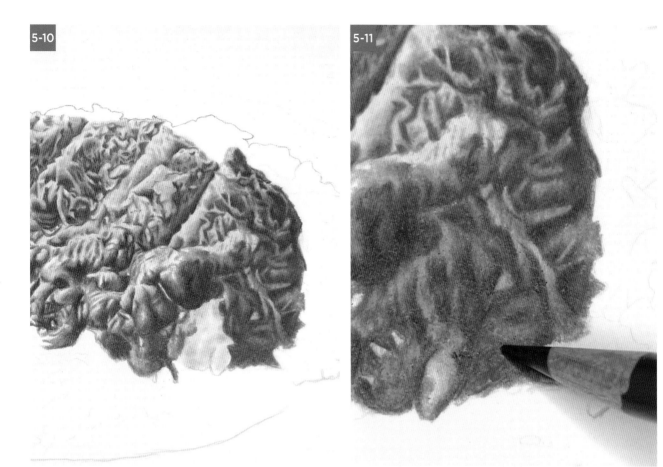

Use colored pencil Nos. 192, 177, 188 and 283 to apply color. Color the darker areas with colored pencil No. 199. Start with light colors and gradually add darker colors. Finally, fine-tune the color with PanPastel® No. 23803.

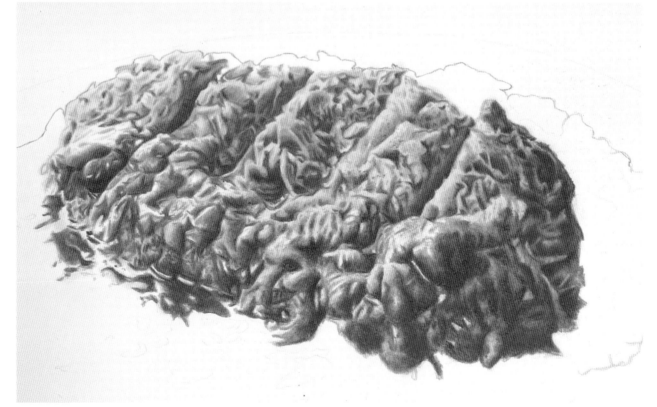

The pork cutlet part is complete.

2 Draw the Curry Sauce

The white of the paper is used as the base for the light reflecting off the surface of the curry sauce. By adding details, such as the protrusion of the ingredients, the thickness of the sauce, and the shadow of the pork cutlets, the sauce looks like curry sauce, even though it is light in color.

THE COLORS USED AT THIS STAGE

COLORED PENCIL	108	177	192	283

PANPASTEL®	27405	28005

● SEARCHING FOR COLORS

The main colors in the photograph are identified at right.

We all have "assumed colors" that we have acquired through experience.

There is an "imagined color" in the human mind. For example, when you take a picture of cherry trees or lemons with a camera, the pink of the cherry blossoms or the yellow of the lemon may appear paler than you expected and you may think, "Oh, what? The color is different!" This is because you have a preconceived notion in your mind. Let us take a good look at the color of curry sauce so that we are not misled by our own preconceived notions of color.

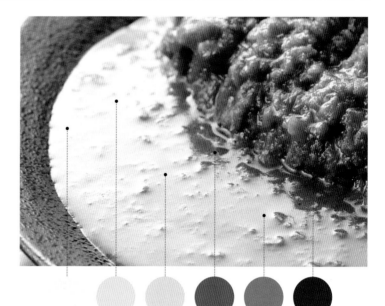

The color is applied as thinly as possible while taking advantage of the white color of the paper.

If an area looks a little brown, color it with a small amount of PanPastel® No. 27405, and fill in the darker areas with colored pencil No. 283. Fill in the areas that look yellow with colored pencil No. 108. Because you do not want the color to be too dark, grip the pencil a little farther away from the tip than usual, and use the side of the lead to apply it.

Adding the shadow of the reflection of the pork cutlet makes it even more realistic.

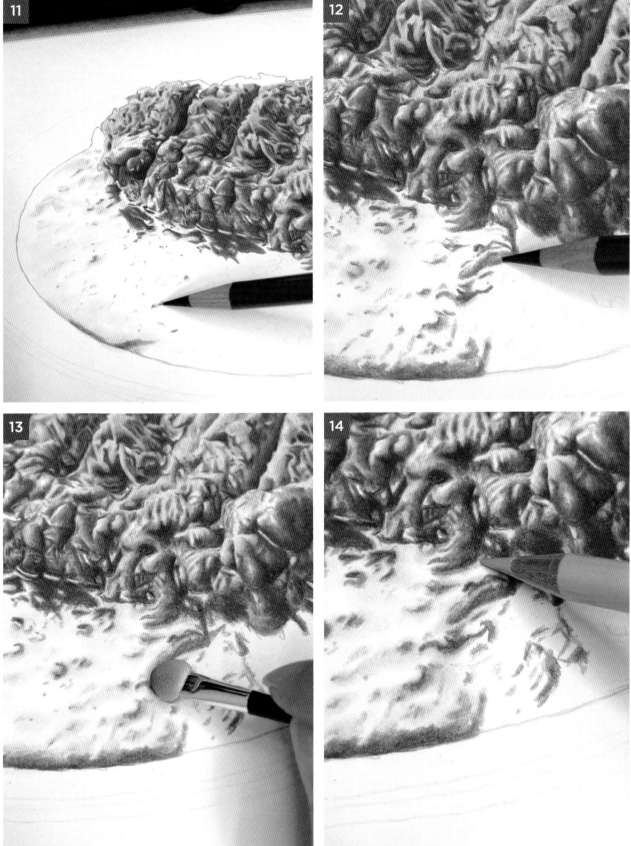

While applying PanPastel® No. 27405, use colored pencil Nos. 108, 177, 283 and 192 to draw in the shadow of the pork cutlet and the color of the curry sauce in the areas that are not directly reflecting light.

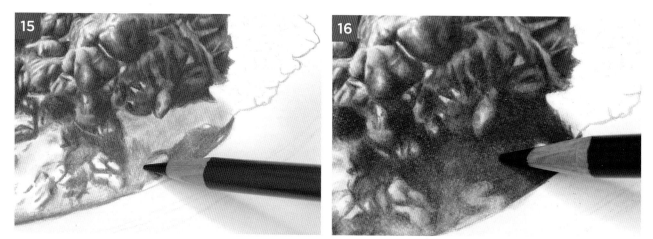

Use colored pencil No. 283 to draw the darker areas on the surface, and then add a base of PanPastel® No. 27405 on the surface before adding the reddish color using colored pencil No. 192.

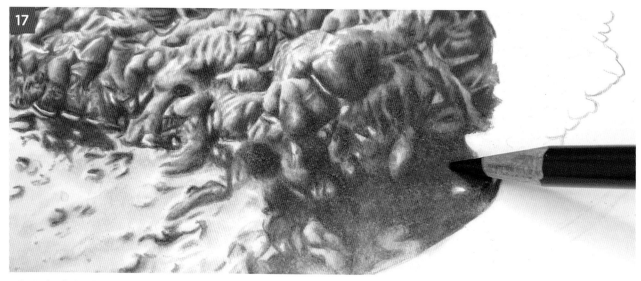

Color in the darker shadow areas with PanPastel® No. 28005, and then color even darker shadows with colored pencil No. 177. Use colored pencil Nos. 283 and 192 to add depth so that the shadows have a natural gradation.

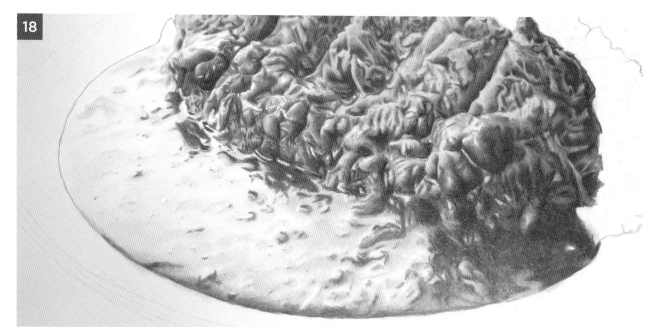

The curry sauce is complete.

3 Draw the Rice

Rice that is white, fluffy and translucent always looks delicious. However, the white color of the paper is not enough to create a sense of three-dimensionality. I have added a light yellow color to the rice and a light gray shadow to each grain.

THE COLORS USED AT THIS STAGE

COLORED PENCIL	102	■ 199	232	270	272
PANPASTEL®	22708				

● SEARCHING FOR COLORS

The main colors in the photograph are identified at right.

The key to drawing rice is to avoid smudging it, muddying it and mixing in blue tones.

If you look closely at the subject photo, you will see that some parts are in focus and some are blurred. If the blurriness can be expressed, the image will look more realistic.

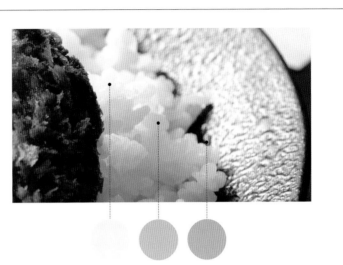

Color the shadow of the rice using colored pencil Nos. 270 and 272 following the line drawing. Use a thin layer of PanPastel® No. 22708 for the color of the entire portion of rice.

Add a little colored pencil No. 102 for the slightly more yellow areas.

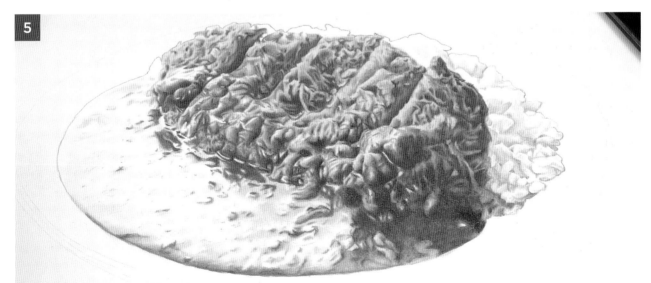

Use colored pencil Nos. 232 and 199 to draw the darker shadows. Finely adjust the color of the entire portion of rice with PanPastel® No. 22708, being careful not to make it too yellow. Because the areas thinly colored with colored pencil will mostly disappear when the PanPastel® is applied, add a little more later on.

4 Draw the Plate and the Shadows

Because the surface of the plate is uneven, the light bounces off it, creating many fine highlights and shadows. The first step is to draw the overall appearance of the plate by looking at the subject photo.

THE COLORS USED AT THIS STAGE

COLORED PENCIL	■	199
PANPASTEL®	■	28005

● SEARCHING FOR COLORS

 The main colors in the photograph are identified at right.

Repeatedly zoom in and out on a PC, tablet or other device to observe the subject photo.

While paying attention to the pressure of the colored pencils, use a strong touch for shadows and dark areas, and a light touch for highlights to express light areas.

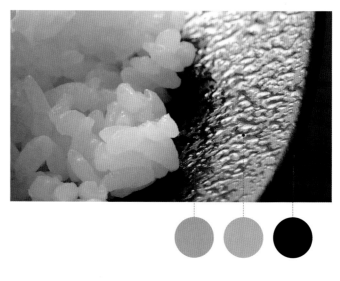

Create the hard texture and feel of the plate.

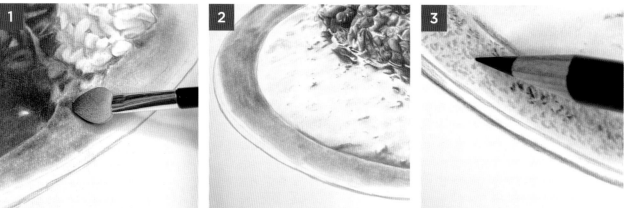

Draw the outlines of the plate with colored pencil No. 199, and then color the base along the outlines using PanPastel® No. 28005. Observe the photo carefully and apply color while paying attention to the shading. Use colored pencil No. 199 to draw the patterns on the plate. Leave the edges of the plate white to give it thickness.

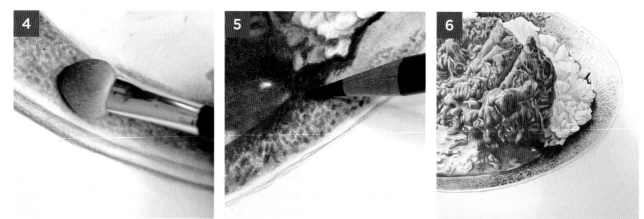

After drawing the pattern, color over it with PanPastel® No. 28005 to blend it in. Color the darker areas more heavily and the areas that will be exposed to light more delicately.

Technique for drawing the texture of the plate

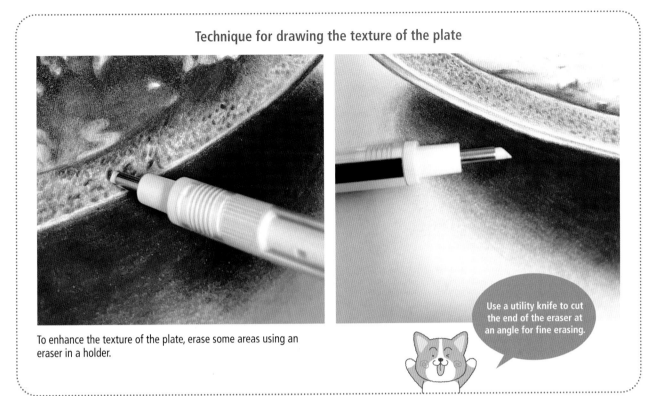

To enhance the texture of the plate, erase some areas using an eraser in a holder.

Use a utility knife to cut the end of the eraser at an angle for fine erasing.

By drawing the shadows well, the realism of the three-dimensional image is increased.

Color in a narrow gradient so that the shadow extends naturally from the plate's ground plane. Apply light and moderate pressure, and check the overall tone of the shadow from a distance to make sure it is not too blurred.

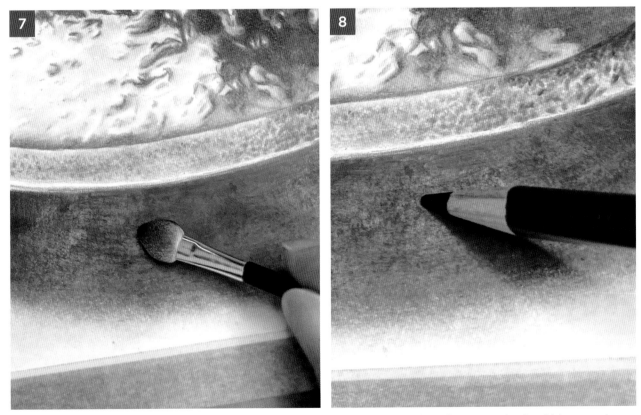

For the shadows, use PanPastel® No. 28005 as the base, and then color more strongly with colored pencil No. 199. Apply color with less strength to make it fade as you move outward, creating natural shadows.

5 Completion

Drawing the curry was a trial-and-error challenge for me. How can I make it look so delicious? I was very frustrated, but I worked on it day after day. Through the filter of "Cocomaru," I am always looking for new ways to depict things. I hope you will also experience the joy of drawing while using this book as a reference.

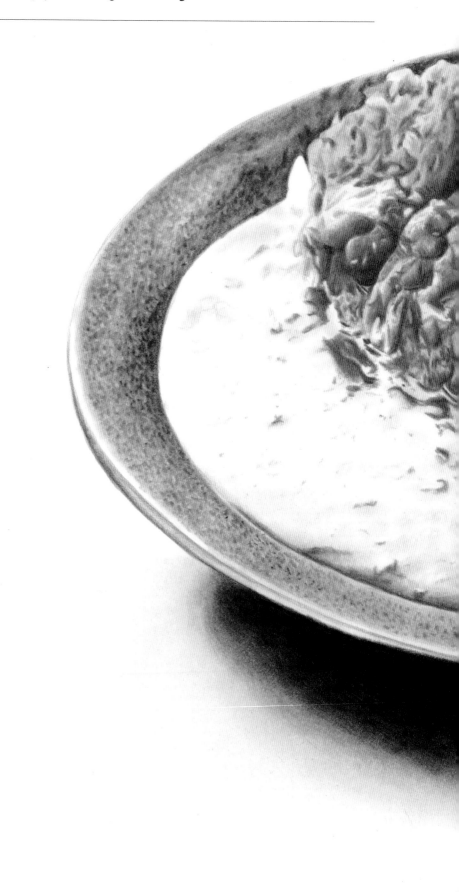

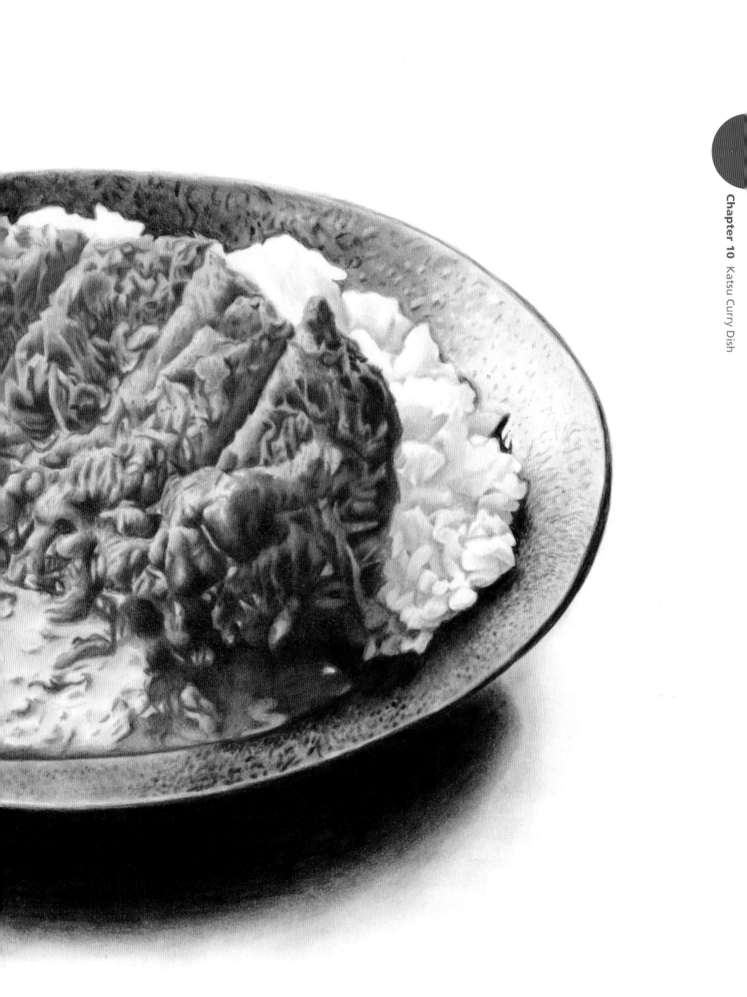

Conclusion

How has your experience using this book been for you? Did you enjoy drawing?

It is quite difficult to draw well initially. I feel that I am getting better at it after completing many drawings.

I believe that the shortcut to progress is to continue to have fun while you draw.

"This time I'll try to draw better than I did before." Try to continue with an easygoing mindset, without setting your sights too high.

I hope this book has inspired you to take up drawing realistically as a new hobby!

—**Cocomaru**

"Daughter" (2020)
MEDIUM: colored pencil and PanPastel®
SIZE: 11⅔ × 8¼ inches (29.7 × 21 cm)

"Books to Span the East and West"

Tuttle Publishing was founded in 1832 in the small New England town of Rutland, Vermont (USA). Our core values remain as strong today as they were then—to publish best-in-class books which bring people together one page at a time. In 1948, we established a publishing outpost in Japan—and Tuttle is now a leader in publishing English-language books about the arts, languages and cultures of Asia. The world has become a much smaller place today and Asia's economic and cultural influence has grown. Yet the need for meaningful dialogue and information about this diverse region has never been greater. Over the past seven decades, Tuttle has published thousands of books on subjects ranging from martial arts and paper crafts to language learning and literature—and our talented authors, illustrators, designers and photographers have won many prestigious awards. We welcome you to explore the wealth of information available on Asia at **www.tuttlepublishing.com.**

Published by Tuttle Publishing, an imprint of Periplus Editions (HK) Ltd.

www.tuttlepublishing.com

ISBN 978-4-8053-1744-0

CHOZETSU REAL NA IROENPITSUGA NO TECHNIQUE
© 2021 Cocomaru
English translation rights arranged with
Seibundo Shinkosha Publishing Co., Ltd.
through Japan UNI Agency, Inc., Tokyo

English translation © 2023 Periplus Editions (HK) Ltd
Translated from Japanese by Makiko Itoh
Photo of colored pencils (top left, front cover)
© Capricorn78/Dreamstime.com

26 25 24 23 10 9 8 7 6 5 4 3 2 1

Printed in China 2307EP

Distributed by:

North America, Latin America & Europe
Tuttle Publishing
364 Innovation Drive
North Clarendon
VT 05759-9436 U.S.A.
Tel: (802) 773-8930
Fax: (802) 773-6993
info@tuttlepublishing.com
www.tuttlepublishing.com

Japan
Tuttle Publishing
Yaekari Building 3rd Floor
5-4-12 Osaki Shinagawa-ku
Tokyo 141 0032
Tel: (81) 3 5437-0171
Fax: (81) 3 5437-0755
sales@tuttle.co.jp
www.tuttle.co.jp

Asia Pacific
Berkeley Books Pte. Ltd.
3 Kallang Sector, #04-01
Singapore 349278
Tel: (65) 6741-2178
Fax: (65) 6741-2179
inquiries@periplus.com.sg
www.tuttlepublishing.com

TUTTLE PUBLISHING® is a registered trademark of Tuttle Publishing, a division of Periplus Editions (HK) Ltd.